STUDENT PRACTICE TESTS

Gene Hood

University of Wisconsin-Eau Claire

A World of Art

Revised Fourth Edition

Henry M. Sayre

University of Oregon - Cascades Campus

PEARSON

Prentice
Hall

Upper Saddle River, New Jersey 07458

© 2005 by PEARSON EDUCATION, INC.
Upper Saddle River, New Jersey 07458

ISBN 0-13-189541-9

Printed in the United States of America

Table of Contents

ABOUT THE
STUDENT PRACTICE TESTS

These Student Practice Tests has been developed to provide guidance to the student in his or her examination of the revised fourth edition of Henry M. Sayre's *A World of Art*.

Each chapter of this book is coordinated exactly with each chapter of Sayre's *A World of Art*. For best results read each of Sayre's chapters first, then return to this book and its corresponding chapter. The questions and exercises in this guide were written to encourage you keep your mind refreshed, and your ideas perceptive. The various exercises are arranged in a progressively sequenced format of multiple-choice questions, fill-in-the-blank questions, true-false exercises, and short answer questions. All of the answers to the questions and exercises are to be found in Henry M. Sayre's textbook, or at the end of this book in the Answer Key portion.

The questions and exercises included in this book were designed to insure a careful and close reading and viewing of the revised fourth edition of *A World of Art*. They will definitely help you to review, and thus study each chapter to better digest the facts, concepts, and ideas contained therein. A side benefit of these tests is apparent as one notices that these questions would make perfect test questions. Answering the multiple-choice, short answer, fill-in-the-blank questions, or performing the true-false exercises will thus help you to prepare for a test based on Sayre's text.

A Test Item File has been prepared for your instructor to accompany the revised fourth edition of Henry M. Sayre's *A World of Art*. Even though the questions in that book are *not exactly the same* as the questions in this book, they have definitely been coordinated to greatly overlap and cover the same material. Studying these questions and actually taking these practice tests would thus be excellent training for your actual course tests.

Instructors--informing students that the questions contained herein greatly resemble your actual test questions will serve to enhance use of this book, and thus greatly increase the instructional power of Sayre's text.

Please note that, in the multiple-choice questions, the answer of "all of these" may be quite correct and thus is used often. As I tell my students, concepts concerning art are often multifaceted and multivalent. The best, most correct answer therefore is often not just one answer but several. Using "all of these" as an answer is useful to encourage you to ponder all of the given possibilities, to better wrestle with the ideas, and--one hopes--to truly understand the material presented.

Gene Hood
University of Wisconsin-Eau Claire

Chapter 1 – A World of Art

Multiple Choice Questions

1. *Umbrellas, Japan and United States* by the collaborative team of Christo and Jeanne-Claude (figs. 1-2; pp. 9-10) involves the specific color scheme of:
 (a) red or green
 (b) magenta or lavender
 (c) orange and turquoise
 (d) blue and yellow

2. Bierstadt's picturesque painting of the Rocky Mountains (fig. 3; p. 11) combines a representation of the Matterhorn in the Swiss Alps with his:
 (a) Polynesian heritage
 (b) World War I experience
 (c) experience of the American West
 (d) Alaskan Expeditions

3. Robert Smithson's *Spiral Jetty* (fig. 6; p. 15) is considered a modern:
 (a) natural sculpture
 (b) earthwork
 (c) portable happening
 (d) aboriginal dance

4. Jasper Johns chose to paint *Three Flags* (fig. 10; p. 18) at a time when America was obsessed with:
 (a) patriotism
 (b) the statehood of Hawaii
 (c) World War I
 (d) Roosevelt's death

5. Faith Ringgold's *God Bless America* (fig. 12; p. 20) was painted during the:
 (a) parade on Allies Day, May 1917
 (b) McCarthy era in the 1950's
 (c) Civil Rights Movement in the 1960's
 (d) Watergate controversy

6. The stripes of the American flag in Faith Ringgold's *God Bless America* (fig. 12; p. 20) are treated as:
 (a) parade marchers
 (b) prison bars
 (c) a heroic memorial
 (d) a ying and yang circle

7. In the painting *Central Mountain* (fig. 4; pp. 12-13), Chinese artist Wu Chen composes according to strict artistic principles of:
 (a) blandness
 (b) dreaming
 (c) unity and simplicity
 (d) verticality

8. Wu Chen's painting *Central Mountain* (fig. 4; pp. 12-13) displays a traditional role of the artist, that is to:
 (a) manifest geometricity
 (b) depict a funeral
 (c) make money
 (d) reveal hidden truths

9. Wu Chen's painting *Central Mountain* (fig. 4; pp. 12-13) is a classic:
 (a) handscroll
 (b) wall mural
 (c) earthwork
 (d) canvas work

10. The organizing logic of Erna Motna's painting *Bushfire and Corroboree Dreaming* (fig. 5; pp. 13-14) is the:
 (a) intellectual poetry
 (b) Dreaming
 (c) ritual hunt
 (d) yin and yang

11. The artist of *Bushfire and Corroboree Dreaming* (fig. 5; pp. 13-14) is an:
 (a) Native American
 (b) African shaman
 (c) Chinese-American
 (d) Australian aborigine

12. In Motna's *Bushfire and Corroboree Dreaming* (fig. 5; pp. 13-14) the Dreaming is not literal, but refers to the:
 (a) intellectual poetry
 (b) presence of an Ancestral Being
 (c) ritual hunt
 (d) yin and yang

13. In Scott Tyler's *Proper Way to View the American Flag* (fig. 13; pp. 20-21), the American flag was placed on the floor underneath:
 (a) photos of flag-draped coffins
 (b) a Buddha figure
 (c) a crucifix
 (d) a large electric fence

2

14. Creativity is the sum of a process (p. 16) that involves:
 (a) seeing
 (b) imagining
 (c) making
 (d) all of these

15. According to Nelson Goodman in *The Language of Art* (p. 18), the eye does not so much mirror, rather it:
 (a) empowers
 (b) alienates
 (c) takes and makes
 (d) complicates

Fill-in-the-Blank Questions

16. According to Sayre (p. 19), the process of "seeing" is both physical and _____ .

17. According to Sayre (p. 19), in the process of seeing, the retina does a lot of _____ .

18. Bierstadt's *The Rocky Mountains* is similar to Robert Smithson's *Spiral Jetty* in that they both show a similar love (p. 17) of the _____ .

19. The depicted subject of Childe Hassam's *Allies Day, 1917* (fig. 9; p. 18) is _____.

20. In *Umbrellas, Japan and United States* ((figs. 1-2; pp. 9-10) by Christo and Jeanne-Claude, the umbrella is a symbol of _____ _____.

21. A traditional role of the artist is to give _____ _____ to ideas, philosophies, or feelings (p. 12).

22. The culture of Chinese artist Wu Chen was dominated (p. 12) by intellectuals who appreciated poetry, painting, wine, and _____ .

23. In Taoist thought (p. 13), the *yin* is passive and _____ .

24. In Taoist thought (p. 13), the *yang* is active and _____ .

25. One traditional role of the artist is to help us see (p. 15) the _____ in an innovative way.

True/False Questions

26. Albert Bierstadt's painting, *The Rocky Mountains,* is true to life. T____ F____

27. The culture to which Wu Chen belonged was dominated by a deep interest in Buddhist and Taoist thought. T____ F____

28. Robert Smithson's *Spiral Jetty* is a traditional landscape. T____ F____

29. Chinese artist Wu Chen was one of the Four Great Masters of the Yuan Dynasty. T____ F____

30. Landscape painter John Constable spoke of the "art of seeing Art." T____ F____

Short Answer Questions

31. In *Umbrellas, Japan and United States* by Christo and Jeanne-Claude, the different colors symbolize what?

32. In the American imagination, what did Albert Bierstadt's painting *The Rocky Mountains* capture?

33. According to H. T. Tuckerman, Bierdstadt's *The Rocky Mountains* seemed to be an image of what?

34. In his painting *Central Mountain*, the artist Wu Chen elevates what to the highest levels of beauty?

35. Because of its components, Smithson's *Spiral Jetty* is a record of what?

Chapter 2 – Developing Visual Literacy

Multiple Choice Questions

1. In Rene Magritte's *The Treason of Images* (fig. 16; p. 24), the point of this art work is the relationship between:
 (a) words
 (b) images
 (c) things in the world
 (d) all of these

2. In Jan van Eyck's painting of *The Marriage of Giovanni Arnolfini* (fig. 32; p. 37), the appearance of the dog at the middle bottom of the painting is:
 (a) a stylistic device
 (b) an iconographic symbol of fidelity
 (c) an insignia of van Eyck brothers
 (d) a result of a misunderstanding by the artist

3. *Grainstack-Snow Effect* (fig. 27; p. 33) is only one of many images of grainstacks Monet painted between 1888 and 1891. The artist intended to express:
 (a) individual landscape elements of Southern France
 (b) his love of farming
 (c) the variety of the natural world's cyclic change
 (d) his feelings of solitude

4. In *Baby Girl* (fig. 23; p. 30) Marisol Escobar creates an abstract work by:
 (a) drawing human form on rounded wood blocks
 (b) rendering the human form exactly
 (c) making his sculpture indistinguishable from a real baby girl
 (d) duplicating an object from the real world

5. Howling Wolf's prison drawing titled *Treaty Signing at Medicine Lodge Creek* (fig. 38; pp. 40-41) depicts the signing of a peace treaty between the US government and the:
 (a) Cheyenne
 (b) Arapaho
 (c) Kiowa
 (d) all of these

6. A work of art like Kasimir Malevich's *Suprematist Painting, Black Rectangle, Blue Triangle* (fig. 26; p. 32) is called nonobjective because it shows:
 (a) natural objects in recognizable form
 (b) slightly recognizable objects
 (c) no reference to the objective world
 (d) objects that fool the eye

7. As we see in *Triumphal Entry* page from the *Shahnamah* manuscript (fig. 17; p. 25), Muslim culture regards the removal of the word from what it refers to as:
 (a) hubris
 (b) a virtue
 (c) a mistake
 (d) dog-like

8. The particular *mudra* hand gestures of this particular *Buddha adorned* (fig. 34; p. 38) symbolize:
 (a) readiness
 (b) meditation
 (c) fertility
 (d) evil

9. The term nonrepresentational art (p. 29) is sometimes used to describe:
 (a) realistic art
 (b) abstract art
 (c) naturalistic art
 (d) nonobjective art

10. Reducing an object from the world to its essential qualities (p. 30) is the method of:
 (a) abstract art
 (b) emotional art
 (c) life casting
 (d) photographic realism

11. Lorna Simpson's multi-panel work *Necklines* (fig. 18; p. 26) is a composition that deals with the ways in which words and images:
 (a) are conventional
 (b) create calmness
 (c) function together
 (d) ignore the viewer

12. Carl Andre's sculpture *Redon* (fig. 25; p. 31) may have a reference in the real world, but Andre is more interested in the:
 (a) human figure
 (b) form
 (c) verisimilitude
 (d) technique

13. In Islamic art (p. 24) because depicting a human is thought to be competing with the "creator," images of humans traditionally are:
 (a) symbols of wealth
 (b) called mullah
 (c) too easy
 (d) banned

14. In a work of art what the work expresses or means (p. 32) refers to the:
 (a) style
 (b) content
 (c) technique
 (d) subject

15. Kenneth Clark shows an ethnocentric reading (p. 34) by stating that an ancient Greek statue represents a "higher state of civilization" than:
 (a) a West African mask
 (b) a Jackson Pollack painting
 (c) French Impressionism
 (d) American baseball

Fill-in-the-Blank Questions

16. The ability to recognize why one likes an art work (p. 23), and how it communicates is called
 _____ _____.

17. Lorna Simpson (pp. 26-27) is preoccupied with the questions of representation and its limitations in her work as a _____ .

18. Your author states that Kenneth Clark's comparative evaluation (p. 34) of the Greek statue and the African mask is ethnocentric, and about the African mask Clark is _____.

19. In van Eyck's Arnolfini marriage portrait (p. 37), the single burning candle in the chandelier symbolizes _____.

20. While in prison Howling Wolf (p. 40) did many renderings executed on blank accountants' books, these are called _____ drawings.

21. As you see in Duane Michals photographic work (pp. 28-29), the subject matter of the work is what the image _____ .

22. The artist who uses the same forms as Monet did in his *Grainstack-Snow Effect* (fig. 27; p. 33), but in a nonobjective way is the Suprematist painter _____ .

23. One of the oldest and finest surviving stained-glass windows in the world (p. 39) dates from 1150 CE, and is from _____ Cathedral.

24. The German word for tree is _____; and the French word for tree is _____.

25. Lorna Simpson's *The Park* (19; p. 27) is actually printed on _____.

True/False Questions

26. The chief form of art in Islamic cultures is called calligraphy. T____ F____

27. Kenneth Clark regards the Sang tribe *African Mask* from Gabon as embodying a higher state of civilization than *Apollo Belvedere*. T____ F____

28. Generally accepted ways of seeing are called conventions. T____ F____

29. For the Baule carvers of the Yamoussoukio area of the Ivory Coast, the helmet mask (fig. 31; p. 35) is an ugly object. T____ F____

30. Cameras never lie. T____ F____

Short Answer Questions

31. Why are the features of the Sang tribe *African Mask* from Gabon exaggerated?

32. Is there another reason why the features of the Sang tribe *African Mask* from Gabon are exaggerated?

33. When viewing Leonardo's *Five Characters* drawing (p. 34-35) with traditional Western conventions, we regard the face as an outward expression of what?

34. A recent controversial argument has been made that, in his famous Arnolfini oil painting (fig. 32; p. 37), Jan van Eyck is not representing a marriage but what?

35. Abbot Suger understood the expressive power of stained-glass windows (p. 39) when he said they transform what into what?

Chapter 3 – The Themes of Art

Multiple Choice Questions

1. In Pierre Auguste Renoir's *Luncheon of the Boating Party* (fig. 39; p. 43), Renoir has created a genre painting; this is a:
 (a) depiction of everyday life
 (b) picture of a king
 (c) rendering of a vase of flowers
 (d) majestic mountain view

2. Kane Kwei's *Coffin Orange* (fig. 59; p. 55), in addition to being practically functional, possesses what significance:
 (a) tool
 (b) grain storage
 (c) ritual
 (d) as a jewelry box

3. Even though Jorn Utzon's Sydney Opera House (fig. 63; p. 57) is largely unsuitable as an opera house, it remains for Sydney:
 (a) an eyesore
 (b) a landmark of civic pride
 (c) a source of great repair expense
 (d) a giant jewel box

4. Salvador Dali's *The Persistence of Memory* (fig. 55; p. 51) uses the style of Surrealism, that is it involves the:
 (a) appeals to the basest instincts
 (b) fools the eye being so accurate
 (c) Dada
 (d) reality of a dream

5. Both de Champaigne's *Still Life* (fig. 65; p. 59) and Robert Mapplethorpe's *Self-Portrait* (fig. 66; p. 59) have the theme of *vanitas*, which is:
 (a) natural beauty
 (b) abstract beauty
 (c) frivolous quality of human life
 (d) political intrigue

6. For many people the main purpose of art (p. 58) is to experience the beautiful. This is our sense of:
 (a) sublime
 (b) aesthetics

(c) picturesque
(d) creativity

7. Throughout the history of the Western world, the representation of the Christian god (p. 49) has consistently aroused:
 (a) desire for materiality
 (b) humble gratitude
 (c) sincere appreciation
 (d) controversy

8. By celebrating a successful life, Kane Kwei's *Coffin Orange* (fig. 59; p. 55) serves a ritual function, but it also:
 (a) is decorative
 (b) carries an image of the deceased on top
 (c) is sculpted to resemble the deceased
 (d) is stamped with the name of the deceased

9. The Africa masks he saw at a museum in Paris affected Picasso's style used in *Les Demoiselles d'Avignon* (fig. 69; pp. 60-61) toward:
 (a) exact representation
 (b) fear yet liberation
 (c) slavish copying
 (d) perfect likeness

10. The purpose of an aesthetic object (p. 58) is to:
 (a) recognize the functional
 (b) grasp the objective
 (c) manifest the utilitarian
 (d) stimulate a sense of beauty

11. A reminder of death (p. 59) is called a:
 (a) trompe l'oeil
 (b) portrait painting
 (c) *momento mori*
 (d) *materiale*

12. Sainte-Chapelle, in the heart of Paris (fig. 62; p. 57), contains some of the most beautiful examples in the world of Gothic:
 (a) stained glass
 (b) secular jewel boxes
 (c) kimonos
 (d) miniature ships

13. Sainte-Chapelle (fig. 62; p. 57) houses:
 (a) royal religious relics
 (b) a piece of the original Cross
 (c) the Crown of Thorns
 (d) all of these

14. The subjectivity of Picasso's *Gertrude Stein* (fig. 54; p. 51) is an example of how subjectivity was fundamental to:
 (a) Matisse
 (b) the history of modern art
 (c) Cubism
 (d) Surrealism

15. Monet's *The Regatta at Argenteuil* (fig. 39; pp. 42-43) is one of the great examples of:
 (a) Suprematism
 (b) Post-Impressionism
 (c) Impressionism
 (d) Surrealism

Fill-in-the-Blank Questions

16. In *vanitas* paintings (p. 59), the *momento mori* aspect is represented by a _____.

17. As seen in Renoir's *Luncheon of the Boating Party* (fig. 57; p. 53), one of the traditional roles of art is genre painting; this means to _____.

18. The God of Pedro Perez, as seen in *God* (fig. 53; p. 50), is an undeniably "cool" _____ _____.

19. As depicted in the panel from the Ghent Altarpiece (fig. 52; p. 29), Jan van Eyck's God apparently values _____.

20. Andy Warhol's banal subject matter in *Big Campbell's Soup Can* (fig. 49; p. 48) is in part a reaction to the _____ _____ of Franz Kline's painting.

21. Franz Kline's *Untitled* painting (fig. 50; p. 48) bears the mark of the artist's _____ and _____.

22. According to your author, the 19th Century (p. 44) is marked by the invention of the greatest imitator of them all, that is _____.

23. In *The Course of Empire* paintings (pp. 44-45) Thomas Cole painted the theme of the _____ _____between nature and civilization.

24. The fifth and last of Thomas Cole's paintings (p. 45) for *The Course of Empire* is _____.

25. In Cole's *The Course of Empire* (pp. 44-45) the permanence of the natural world is symbolized by _____.

True False Questions

26. Both Thomas Cole and Claude Monet depict the world as they do
in order to be neutral and objective. T ____ F____

27. Donald Judd's minimalist sculpture *Untitled* (fig. 51; p. 49) is
mechanically impersonal. T ____ F____

28. Impressionism (p. 42) takes its name from a particular way of seeing. T ____ F____

29. Monet's purpose (p. 43) is to support the traditional nature of representation. T ____ F____

30. Manet's *Asparagus* (fig. 58; p. 54) suggests sensual engagement. T ____ F____

Short Answer Questions

31. Robert Motherwell refused to admit that a work like his *Elegy to the Spanish Republic No. 34* (fig. 56; p. 52) was what?

32. In its sheer beauty, the *Karaori* kimono (fig. 61; p. 56) announces what about the character who would wear it?

33. Mathias Grunewald's *Crucifixion* from the *Isenheim Altarpiece* (fig. 64; p. 58) was painted for what specific place, which probably affected its appearance?

34. Perhaps the object upon which cultures lavish their attention (p. 56) most is what?

35. In his advice to Lilly Cabot Perry, Monet suggested that when painting she should "try to forget" (p. 43) what?

Chapter 4 – Seeing the Value in Art

Multiple Choice Questions

1. In 1863 because of its modernity, Edouard Manet's *Dejeuner sur l'herbe* (fig. 74; pp. 66-67) was:
 (a) shipped to America
 (b) burned by a mob
 (c) rejected by the public
 (d) purchased by the government

2. Controversial at first because of its non-traditional style, Maya Lin's *Vietnam War Memorial* (fig. 80; p. 70) is now:
 (a) rejected by the public
 (b) the most visited site in Washington
 (c) transplanted to Los Angeles
 (d) located in Beijing

3. Marcel Duchamp's *Nude Descending a Staircase* (fig. 76; p. 68) was at the center of a scandal at a famous 1913 exhibition in New York called:
 (a) Salon des Refusees
 (b) la Biennnale
 (c) Prix de Rome
 (d) the Armory Show

4. Michelangelo's *David* (fig. 85; p. 74) came under attack at first viewing because it symbolized:
 (a) Republican Florence
 (b) the hand of God
 (c) Duke Sforza
 (d) the *arringiera*

5. The *Aids Memorial Quilt* (fig. 93; p. 79) today cannot be shown in its entirety because it:
 (a) is too controversial
 (b) is too large
 (c) scandalized the Church
 (d) offends Jesse helms

6. Alexander Calder's large red public sculpture *La Grande Vitesse* (fig. 81; p. 71) in Grand Rapids, Michigan is today a source of:
 (a) great revenue
 (b) police brutality
 (c) public discord
 (d) civic pride

7. In Guillermo Gomez-Pena's performance and installation work titled *Temple of Confessions* (fig. 90; p. 77), the artist sits dressed as:
 (a) a political leader
 (b) academic philosopher
 (c) curio shop shaman
 (d) black-draped mourner

8. Jesse Helms introduced a bill in Congress (p. 64) prohibiting the use of what for "dissemination, promotion, or production of obscene or indecent materials, or materials denigrating a particular religion"?
 (a) NEA funds
 (b) the FBI
 (c) private donations
 (d) presidential authority

9. The public's understanding of what the artist is trying to say (p. 66) has a large influence upon the relation between the:
 (a) patron and audience
 (b) artist and public
 (c) union and critics
 (d) dealer and agent

10. What now-famous work was rejected in1863 from the annual Salon exhibition (p. 66) in Paris?
 (a) Ofili's *Grande Palais*
 (b) Picasso's *Gertrude Stein*
 (c) *Les Demoiselles d'Avignon*
 (d) Manet's *Dejeuner sur l'herbe*

11. In 1913 Duchamp's *Nude Descending a Staircase* (fig. 76; p. 68) was referred to as:
 (a) reminiscent of a Navajo blanket
 (b) a staircase descending a nude
 (c) an explosion in a shingle factory
 (d) all of these

12. Historically, because the public usually has little context in which to view innovative art (p. 68), it tends to receive it with:
 (a) great celebration
 (b) enthusiasm
 (c) reservation
 (d) ironic detachment

13. Because they all were initially misunderstood by the public (p. 70), works by Manet and Duchamp and what more recent artist are similar:
 (a) Etienne Jules Marey
 (b) Maya Lin
 (c) Raimondi
 (d) Muybridge

14. In 1967 the Arts in Public Places Program of the NEA (p.71) made works of art available to the:
 (a) Congress
 (b) general public
 (c) District of Columbia
 (d) National Gallery

15. Richard Serra's public sculpture *Tilted Arc* (fig. 84; p. 73) was eventually:
 (a) moved to France
 (b) accepted and celebrated by the public
 (c) destroyed
 (d) victorious in court

Fill-in-the-Blank Questions

16. The *AIDS Memorial Quilt* (p. 79) was organized by _____.

17. The Armory Show was the first exhibition to expose (p. 68) most Americans _____
 ___.

18. The artist whose art consists of vehicles for the homeless (p. 75) is _____ _____.

19. Etienne-Jules Marey called his unusual motion photographs (p. 69) of the model in the black suit_____.

20. Alexander Calder's *La Grande Vitesse* (fig. 81; p. 71) was the first work commissioned by the _____.

21. For artist Guillermo Gomez-Pena (p. 76) the entire problem, that is the major political question facing North America, is the idea of the _____ .

22. Gomez-Pena's work (pp. 76-77) is an ongoing series of what he calls _____ _____.

23. *In Mourning and Rage* (fig. 90; p. 78) took this culture's trivialized images of mourners as powerless women and transformed them into_____ angrily demanding an end to violence.

24. Lacy and Labowitz's *In Mourning and Rage* (p. 78) presents an example of the artist as _____.

25. When one considers how the artist can affect and change the world (p. 66) to make it a better place, one is considering questions of _____.

True False Questions

26. In the Cincinnati trial of Dennis Barrie (p. 64), the jury ruled that each of the Mapplethorpe photographs lacked serious artistic value.　　T ____ F____

27. Emile Zola wrote a barely fictionalized account of the public reception of Manet's *Luncheon on the Grass* (p. 66).　　T ____ F____

28. Baby angels popular in Renaissance art (p. 65) are known as *putti*.　　T ____ F____

29. New York Mayor Giuliani (p. 65) called Chris Ofili's work "sick stuff."　　T ____ F____

30. Eadweard Muybridge's photographs of a horse trotting were influenced by Marey's book *Movement* (p. 68).　　T ____ F____

Short Answer Questions

31. The composition of Manet's *Luncheon on the Grass* (p. 66) is based on a composition by what famous Renaissance artist?

32. Suzanne Lacy's chart, Spectrum of the Artists' Roles, shows the artist (p. 66) acting in what modes?

33. What most irritated both critics and public about Manet's *Luncheon on the Grass* (p. 66)?

34. How did Karl Marx (p. 67) describe Edouard Manet's treatment of the conditions of contemporary social life?

35. In *Luncheon on the Grass* Manet rejected traditional painting techniques (p. 67) precisely to draw attention to what?

Chapter 5 – Line

Multiple Choice Questions

1. In Vincent van Gogh's *The Starry Night* (fig. 106; p. 86-87), we note that much of the emotional power of the work stems from the artist's use of an expressive line that is so:
 - (a) loose and free
 - (b) cantilevered
 - (c) implied
 - (d) dead

2. In Ingres's *The Turkish Bath* (fig. 123; p. 99) the artist uses contour line, outline, and implied line. Yet he uses circles within circles to:
 - (a) create a grid
 - (b) celebrate the masculine
 - (c) organize the work
 - (d) embody the sultan

3. In Pat Steir's series *The Drawing Lesson* (figs. 103, 105; pp. 86-87), each pair of works represents a particular quality of line that is:
 - (a) expressive
 - (b) intellectual
 - (c) emotional
 - (d) all of these

4. Titian's *Assumption and Consecration of the Virgin* (fig. 101; p. 85) demonstrates the strength of lines of sight; this is one of the most powerful types of:
 - (a) expressive line
 - (b) implied line
 - (c) textured line
 - (d) contour line

5. In order to indicate the waving motion of hands in his *Untitled* drawing (fig. 98; p. 83), Keith Haring uses:
 - (a) contour lines
 - (b) textured lines
 - (c) actual lines
 - (d) implied lines

6. Alexander Calder's *Dots and Dashes* (fig. 99; p. 84) is an excellent example of kinetic art, that is a work that:
 - (a) is fun
 - (b) moves
 - (c) connotes
 - (d) surrounds

7. In his work *Lines From Four Corners to Points on a Grid* (fig. 110; p. 90), Sol LeWitt uses an analytic line that is:
 (a) precise
 (b) logical
 (c) mathematically rigorous
 (d) all of these

8. In *Three Fujins* (fig. 117; p. 95), Hung Liu uses carefully drawn structural lines and uncontrolled painted drip lines, because what is very important to her?
 (a) contrast
 (b) her need to paint
 (c) lack of control
 (d) spiritual captivity

9. What kinds of works (p. 84) of art utilize movement to create implied lines and a sense of virtual volume?
 (a) drawings
 (b) outlined
 (c) kinetic
 (d) conceptual

10. Implied lines depend on our perception (p. 83), and are created by a sense of:
 (a) visibility
 (b) tangibility
 (c) movement
 (d) action

11. Lines that are suggested (p. 83) by nodding, pointing or by following something that is indicated but invisible are:
 (a) negative lines
 (b) constructivist lines
 (c) contour lines
 (d) implied lines

12. It has been suggested of J. A. D. Ingres (p. 98), that probably no painter better explored the expressive qualities of the curve as it relates to the:
 (a) triangular composition
 (b) female body
 (c) circular form
 (d) virtual volume

13. Because Hung Liu studied and taught painting (p. 94) of a Russian Social Realist style, in her works she employed lines that are:
 (a) strict, classical
 (b) abstract expressionist
 (c) post-impressionist
 (d) expressively romantic

14. When a style of line (p. 87) is termed autographic, this means it:
 (a) is like a signature
 (b) identifies the artist
 (c) is recognizably of one artist
 (d) all of these

15. The 19ᵗʰ century style of art that attempted to express all feelings and passion is called:
 (a) Classical
 (b) Rational
 (c) Romantic
 (d) Socratic

Fill-in-the Blank Questions

16. Historically, many cultural assumptions have been made about line. Greek art of the fifth century BCE probably acts as the basis for _____ line.

17. According to Sayre, line is "above all, the artist's most basic_____."

18. In *Untitled* (fig. 98; p. 83), Keith Haring employed two types of lines: actual lines indicating the motion of waving hands and also _____.

19. The pattern of vertical and horizontal lines (pp. 90-91) crossing one another to make squares is called the _____ .

20. As Calder's *Dots and Dashes* (fig. 99; p. 84) moves, the lines it generates are equivalent (in the artist's mind) to the lines created by a _____ .

21. Line is perhaps (p. 82) the most _____ element of art.

22. In painting, the way the artist chooses to organize the canvas (p. 82) is called the _____

23. The French terms for still life (p. 82) are _____ _____ .

24. When volumes make lines appear to us as they curve away (p. 83), these lines are called ____ _____ lines.

25. In his *Assumption and Consecration of the Virgin* (fig. 101; p. 85), Titian employs interlocking _____ _____to unify the divine and mortal worlds.

True False Questions

26. Pat Steir (p. 86) calls *Drawing Lesson, Part I, Line* "a dictionary of marks." T _____ F_____

27. Ingres was most interested (p. 98) in absolutely accurate anatomy. T _____ F_____

28. Ingres often manipulates female anatomy (p. 98) to satisfy needs of design. T _____ F_____

29. Poseidon (p. 96) was the Greek god of the sea. T _____ F_____

30. Lisa Lyon (p. 97) was the main subject for Pat Steir's *Drawing Lesson* series. T _____ F_____

Short Answer Questions

31. How does Praxiteles treat the female figure in his *Aphrodite of Knidos* (fig. 119; p. 96)?

32. In his *Jupiter and Thetis* (fig. 120; p. 97), with what lines does Ingres define Jupiter?

33. In *Jupiter and Thetis* what sexist implications does Ingres associate with the male?

34. Ingres seems to regard Thetis (p. 97) as the embodiment of what qualities?

35. What does the author call Jasper Johns's loose, fluid brushwork seen in *Numbers in Color* (fig. 111; p. 91)?

Chapter 6 – Space

Multiple Choice Questions

1. As a result of the one-point linear perspective of Leonardo da Vinci's *The Last Supper* (fig. 136; p. 106) the gaze of Christ seems to:
 (a) burn through Judas
 (b) control the world
 (c) suspend time
 (d) leap outside the picture

2. Gustave Caillebotte's *Place de l'Europe on a Rainy Day* (fig. 138; p. 106) employs two-point linear perspective, which helps to create a(n):
 (a) isometric view
 (b) trimetric angle
 (c) lively composition
 (d) psychological intensity

3. Peter Paul Rubens's painting *The Kermis* (fig. 143; p. 109-111) celebrates:
 (a) marriage
 (b) Rubens himself
 (c) growing old gracefully
 (d) raw appetite

4. Because Matisse was interested in compositional elements and not pure *verisimilitude,* his *Harmony in Red* (fig. 154; p. 116) deliberately:
 (a) violates the laws of perspective
 (b) exudes psychological expression
 (c) he was seems formally boring
 (d) has great accuracy of detail

5. Cezanne's *Madame Cezanne in a Red Armchair* (fig. 156; p. 116-117) shows that the artist was interested in
 (a) design
 (b) the activity of painting
 (c) play of pattern and color
 (d) all of these

6. As is common in Japanese art, the Kumano Mandala (fig. 149; p. 112) utilizes oblique projection to:
 (a) emphasize unity
 (b) stress monocular vision
 (c) create the illusion of space
 (d) suggest tension

7. Andrea Mantegna uses foreshortening in *The Dead Christ* (fig. 154; p. 115) to:
 (a) manifest chiaroscuro
 (b) adjust the distortion created by the point of view
 (c) project the design
 (d) express reverence

8. In the *Rubin Vase* (fig. 127; p. 102), we see the relationship called figure-ground reversal; this is when the:
 (a) linear perspective distorts the middle ground
 (b) the black appears as vase or background space
 (c) foreshortening is uncorrected
 (d) vanishing point moves up front

9. Two sculptural art works that both have positive forms containing negative space are the African Feast-Making Spoon (fig. 130; p. 103) and:
 (a) Mantegna's *Dead Christ*
 (b) Diebenkorn's *Women in Chaise*
 (c) Puryear's *Self*
 (d) Hepworth's *Two Figures*

10. Monocular vision (p. 113) is when a picture drawn in perspective employs a point of view that is:
 (a) one-eyed
 (b) depthless
 (c) pyramidal
 (d) expressive

11. The stereoscope (p. 113) is such an effective means of describing "real" space by mimicking binocular vision, precisely because it results from:
 (a) a computer
 (b) the divergence of points of view
 (c) two loudspeakers
 (d) six photos

12. In a painting or drawing, the picture plane (p. 104) is the:
 (a) deep space
 (b) artist's viewpoint
 (c) surface of the work
 (d) composition

13. A spatial projection (p. 112) in which all lines indicating height, width, and depth remain parallel is called:
 (a) perpendicular
 (b) parallel
 (c) diagonal
 (d) axonometric

14. According to Sayre, our notion of space has changed abruptly since the beginning of the 20th century (p. 100) with Einstein's theories, even seeming to become:
 (a) perspectival
 (b) adventurous
 (c) static
 (d) fluid

15. In 1986 architect Gae Aluenti converted a railway station into the Musee d'Orsay (fig. 128; p. 102) by adding cubical and rectilinear galleries, all the while maintaining the:
 (a) space defined by the original architecture
 (b) cruciform plan
 (c) pyramidal entrance foyer
 (d) flying buttresses

Fill-in-the Blank Questions

16. Because two-dimensional space is flat, a sense of depth (p. 104) on a two-dimensional surface can be achieved only by _____.

17. Change of scale and overlapping are techniques (p. 104) artists have used to convey the illusion of deep space on a _____.

18. Trimetric and isometric (p. 112) are types of _____ projection.

19. Perspective is a system known to the Greeks (p. 105), but it was not _____ ____until the Renaissance.

20. In linear perspective, the_____ _____ is located (p. 105) on the viewer's horizon.

21. The instant a _____ is placed on a ground (p. 102), a sense of space is activated.

22. When there are two vanishing points (p. 106) then _____-_____ linear perspective is being employed.

23. Because of the convincing one-point linear perspective in his mural of *The Last Supper* (fig. 136; p. 106), Leonardo is able to organize the space of the painting around _____.

24. The space of *The Last Supper* (fig. 136; p. 106) was created as an extension of the space in the _____ of the Monastery of Santa Maria delle Grazie in Milan.

25. A _____ is a solid that occupies a three-dimensional volume.

True False Questions

26. Shape (p. 101) is deep and massive. T _____ F_____

27. Rubens' *The Kermis* is related thematically to Brouwer's
Peasant Dance (p. 110). T _____ F_____

28. The use of space in Rubens' *Kermis* enhances the content of the picture. T _____ F_____

29. New technologies are not affecting (p. 100) our sense of space. T _____ F_____

30. Brueghel's *The Wedding Dance* (fig. 142; p. 109) is balanced. T _____ F_____

Short Answer Questions

31. The vanishing point of Brueghel's *The Wedding Dance* (p. 108) is on the horizon where?

32. If the vanishing point is to one side or the other in a composition (p. 105), the recession is said to be what?

33. If the vanishing point is directly across from the viewer's vantage point (p. 105), the recession is said to be what?

34. In Richard Diebenkorn's *Woman in Chaise* (fig. 131; p. 104), the untouched white ground of the paper is called what?

35. In an illusionistic two-dimensional art work, objects closer to the viewer (p. 104) do what to objects that appear to be behind?

Chapter 7 – Light and Color

Multiple Choice Questions

1. Le Corbusier's Interior of Notre-Dame-du-Haut (fig. 160; p. 121) is one of the most dramatically lit spaces in modern architecture because the:
 (a) light is all chartreuse
 (b) light possesses a spirituality
 (c) space is huge
 (d) choir loft is so high

2. In her painting *Judith and Maidservant with the Head of Holofernes* (fig. 167; p. 124-125) Artemisia Gentileschi heightens the drama of this scene by using tenebrism; this is a technique that means:
 (a) cross-hatching
 (b) simultaneous contrast
 (c) murky
 (d) black

3. In his *A Sunday on La Grande Jatte* (fig. 189; p. 139) Seurat believed that by painting with thousands of tiny dots of color, called pointillism, the viewer's eye would:
 (a) perceive the hidden symbolism
 (b) see cross-hatching
 (c) construct a new reality
 (d) mix colors optically

4. Mary Cassatt's *In the Loge* (fig. 170; p. 126-127) is a study in contrast between:
 (a) light and dark
 (b) tenebrism and chiaroscuro
 (c) verticals and diagonals
 (d) shape and volume

5. The color scheme in Sanford R. Gifford's *October in the Catskills* (fig. 186; pp. 136-137) consists of warm colors; thus in varying degrees of intensity we see:
 (a) greens and violets
 (b) yellows, oranges, and reds
 (c) blues and greens
 (d) tertiaries

6. Turner certainly used linear perspective in *Rain, Steam and Speed—The Great Western Railway* (fig. 162; p. 122), but the space of the painting is dominated by the:
 (a) luminous perspective
 (b) aerial perspective
 (c) two-point linear perspective
 (d) axonometric projection

7. In his *Head of a Satyr* (fig. 168; p. 125), Michelangelo utilized cross-hatching to achieve the sense of:
 - (a) volume and form
 - (b) shape and color
 - (c) axonometric projection
 - (d) deep space

8. The author describes Chuck Close's painting *Stanley* (fig. 193; p. 141) as:
 - (a) layered pointillism
 - (b) made up of micro-paintings
 - (c) reproducing the abstract design of the photo's grid
 - (d) all of the above

9. Charles Searles's painting *Filas for Sale* (fig. 194; p. 142) uses a polychromatic color scheme, that is:
 - (a) only complementary hues
 - (b) primarily tertiaries
 - (c) the entire range of hues
 - (d) a closed palette

10. One of the chief tools employed by Renaissance artists to render the effects of light (p. 124) was chiaroscuro, that is:
 - (a) greens and yellows
 - (b) the balance of light and shade
 - (c) murky highlights
 - (d) the perceptual key

11. In 1905 Albert Munsell came up with a different color wheel (fig. 190; p. 139) that better accounts for one of the most powerful complementary color relationships, that is:
 - (a) blue and red-orange
 - (b) green and red
 - (c) orange and blue
 - (d) yellow and blue-violet

12. The intensity of a color (p. 134) is a function of the color's relative:
 - (a) brightness or dullness
 - (b) refraction key
 - (c) lightness or darkness
 - (d) medium

13. On the color wheel, the cool range (p. 137) refers to:
 - (a) yellow to red
 - (b) black to grey
 - (c) green through violet
 - (d) orange to blue

14. On the conventional color wheel (p. 133), an intermediate color lies <u>directly</u> between:
 (a) tints
 (b) a secondary and primary
 (c) shades
 (d) two secondary colors

15. Artists sometimes choose to expressively employ arbitrary color (p. 145), this occurs when the artist paints things:
 (a) in colors that are not "true"
 (b) not in their correct optical color
 (c) not in their local color
 (d) all of these

Fill-in-the-Blank Questions

16. The color mixture of yellow-green (p. 120) is also called _____.

17. The range of colors (p. 135) that an artist prefers to use is called _____.

18. Among the three basic areas of shadow (p. 124), the darkest area of all is the _____ _____.

19. Whenever black is added to a hue (p. 128) we are dealing with a _____.

20. Whenever white is added to a hue (p. 128) we are dealing with a _____.

21. Up to ten million different colors (p. 132) may be distinguished by the_____.

22. When the total spectrum of refracted light (p. 134) is recombined, _____ results.

23. The easiest way for an artist to lower a hue's intensity or saturation (p. 134) is to add _____.

24. The three primary colors (p. 133) are blue, yellow, and _____ .

25. On the traditional color wheel, the complementary color (p. 138) to blue is _____.

True False Questions

26. So-called "color blind" people do not experience spatial relationships differently from the rest of us. T _____ F_____

27. When both warm and cool hues occur together in the same work (p. 137) they tend to evoke a sense of tension. T _____ F_____

28. Analogous color schemes (p. 137) are composed of those hues that are opposite each other on the color wheel. T _____ F_____

29. For Wassily Kandinsky (p. 149), blue was the heavenly color. T _____ F_____

29. The red tree in Stuart Davis's *Summer Landscape* (fig. 199; p. 143) is an example of local color. T _____ F_____

Short Answer Questions

31. The restoration of the Sistine Chapel ceiling frescoes (p. 135) would seem to change our notion of Michelangelo's art, particularly his what?

32. Placing two complements next to each other (p. 139) without mixing creates what effect?

33. In his painting *The Night Café* (fig. 202; p. 148), van Gogh employs red and green to what end?

34. Sonia Delaunay-Terk (p. 146) explored "the beautiful fruit of light"; this refers to what?

35. In the colors of *Electric Prism* (fig. 201; p. 147), Sonia Delaunay-Terk believed that she had joined herself to the what of modernity?

Chapter 8 – Other Formal Elements

Multiple Choice Questions

1. We can see that Sassetta's *Meeting of St. Anthony and St. Paul* (fig. 214; p. 157) was intended to be a temporal experience because it depicts:
 - (a) St. Anthony at three different points
 - (b) the process of painting
 - (c) a representation of a miracle
 - (d) part of a diptych

2. Jean Tinguely's *Homage to New York* (fig. 221; p. 162) is a work that sputtered, stalled, erupted, self-destructed, and moved; it is thus an example of:
 - (a) drawing
 - (b) talking art
 - (c) kinetic art
 - (d) optical painting

3. Because Michelangelo's *Pieta* (fig. 205; p. 152) is made of marble and the artist has transformed it into lifelike form, we are virtually compelled to touch the work; it is therefore:
 - (a) kinetic
 - (b) tactile
 - (c) optical
 - (d) impasto

4. The systematic and repetitive use of the same motif or design on this Lotto rug, Anatolia (fig. 210; p. 155) creates an important decorative tool we know as:
 - (a) temporality
 - (b) homage
 - (c) media
 - (d) pattern

5. In *Europe After the Rain* (fig. 208; p. 154) Max Ernst used *frottage*, which is:
 - (a) trompe l'oeil
 - (b) raking light
 - (c) a wide variety of rubbed textural effects
 - (d) pasted enamel paint

6. Early manuscripts such as the *Lindisfarne Gospels* (fig. 211; p. 155) are said to be illuminated or:
 - (a) reflective of the power of the church
 - (b) elaborately illustrated and decorated
 - (c) showing beautiful figurative drawing skills
 - (d) an early example of aerial perspective

7. A friend of Monet's described his great paintings of *Waterlilies* in the Musee de l'Orangerie (fig. 215; p. 159) as demonstrating Brownian motion, which is the result of:
 (a) motion of suspended particles in fluid
 (b) autumnal rhythm
 (c) mechanized interaction
 (d) religious zealotry

8. Hans Namuth's photos show us (pp. 160-161) that Jackson Pollock longed to be involved in his work and in the process of painting, and thus he painted on:
 (a) an easel
 (b) the floor
 (c) Impressionist masterpieces
 (d) a mechanized wall

9. Pattern (p. 155) results from our recognition of:
 (a) relief painting
 (b) utilitarian objects
 (c) trompe l'oeil
 (d) any formal element that repeats itself

10. The use of decorative pattern (p. 155) has been associated with:
 (a) folk art
 (b) beautifying utilitarian objects
 (c) quilt-making
 (d) all of these

11. Optical Painting or "Op Art" works (p. 162) are created precisely to give us the illusion or sensation of:
 (a) self-destruction
 (b) movement
 (c) animalism
 (d) decoration

12. Impasto (pp. 152-154) is:
 (a) brushstrokes with seeming body
 (b) an actual textural effect
 (c) paint applied a thick, heavy manner
 (d) all of these

13. Monet's large-scale lily pond paintings (p. 159) require one to view them over time; they may thus be considered:
 (a) spatial
 (b) illusion
 (c) temporal
 (d) kinetic

14. The directness, realism, and immediacy of television (p. 164) have caused it to be considered the most:
 (a) entertaining choice
 (b) realistic of media
 (c) immoral imagery
 (d) all of the above

15. The video images in Bill Viola's *Room for St. John of the Cross* (figs. 225, 226; p. 165) would not be appropriate for broadcast television because they are:
 (a) too abstract
 (b) too erotic
 (c) too monotonous
 (d) too poetic

Fill-in-the-Blank Questions

16. Kinetic sculptures are sculptures that _____ .

17. The word we use to describe the work of art's ability (p. 152) to call forth tactile sensations is _____.

18. The textural effect of a thick brushstroke (p. 152) is called _____ .

19. _____ is a tactile quality that appears to be actual (p. 154) but is not.

20. The French word *frotter* (p. 154) means _____ .

21. The use of intricate, ribbon-like traceries of line (p. 155) that suggest wild beasts is called _____.

22. We find intricate, ribbon-like traceries of line (p. 155) that suggest wild beasts and a checkerboard pattern in an eighth-century work called the _____.

23. Miriam Schapiro's large work *Barcelona Fan* (fig. 212; p. 156) is an example of a _____.

24. Pattern's repetitive quality (p. 156) creates a sense of _____ and directional movement.

25. Because Bernini's *David* (fig. 213; p. 157) seems caught in the midst of action, and because it implies the figure of Goliath, we feel that it is a single moment taken from a larger story; it is thus _____.

True False Questions

26. When Pollack was painting (p. 161) his movements were stiff and jerky. T _____ F_____

27. In Riley's *Drift 2* (fig. 220; p. 162) we encounter wave action. T _____ F_____

28. In the 20th century the spatial and temporal have not been combined in art. T _____ F_____

29. *The Great Train Robbery* was the first narrative-action-chase scene
 in the history of the cinema. T _____ F_____

30. Time and motion are the same in television and video art. T _____ F_____

Short Answer Questions

31. Because the drips and sweeps of paint record the artist's action (as in Pollack's *No. 29*; fig. 219; pp. 160-161) they are labeled what?

32. In Bill Viola's work *Room for St. John of the Cross* (figs. 225, 226; p. 165) what is barely audible?

33. One tongue-in-cheek critic of Tinguely's *Homage to New York* (fig. 221; p. 162) believed that it represented what for civilization?

34. At the Orangerie museum in Paris, the large-scale water lily paintings of Monet do what to the room?

35. Garnett's *Erosion and Strip Farms* (fig. 209; p. 154) is a work in what medium?

Chapter 9 – The Principles of Design

Multiple Choice Questions

1. Because everyone in Japan knows how large Mount Fuji is, Hokusai's *The Great Wave* (fig. 251; p. 183) plays with the viewer's expectations by manipulating:
 (a) patriotism
 (b) little people
 (c) scale
 (d) all of the above

2. Chartres Cathedral's *Rose Window* (fig. 235; p. 173) is a perfect illustration of radial balance because:
 (a) it is balanced via radio waves
 (b) everything radiates outward from a central point
 (c) the forms resemble tires
 (d) of its asymmetrical façade

3. In Quarton's *Coronation of the Virgin* (fig. 231; p. 169) the cruciform shape:
 (a) acts to organize all the formal elements
 (b) is a small detail
 (c) dominates the whole
 (d) all of these

4. In Judy Baca's *La Memoria de Nuestra Tierra* (fig. 253; pp. 184-185), what is everywhere an issue is this work?
 (a) scale
 (b) grid
 (c) dark earth
 (d) Mt. Fuji

5. Slide: Nancy Graves' *Zeeg* (fig. 232; p. 170) is a good example of asymmetrical balance; this is when there is balance but:
 (a) two sides are the same
 (b) bottom and top match
 (c) two sides are not the same
 (d) the center is empty

6. When an artist creates a work that is afocal (p. 177), this means that:
 (a) no single point demands our attention
 (b) the eye finds no place to rest
 (c) your vision seems to focus on nothing at all
 (d) all of these

7. Leonardo da Vinci's *Proportions of the Human Figure* (fig. 227; p. 167) unites qualities of:
 (a) balance and emphasis
 (b) proportion and scale
 (c) rhythm and repetition
 (d) all of these

8. In Jacques-Louis David's *Oath of the Horatii* (fig. 239; p. 176), the three swords and outstretched right arm of the central figure form the:
 (a) vanishing point
 (b) focal point
 (c) afocal zone
 (d) light source

9. The golden section was made famous by the ancient Greeks (p. 187) as a model of:
 (a) architectural proportion
 (b) the Doryphorus
 (c) the canonical façade
 (d) asymmetrical balance

10. All art deals with visual weight (p. 168); this is the:
 (a) material weight on a scale
 (b) proportion of space to solids
 (c) apparent heaviness of arranged compositional forms
 (d) balance between form and content

11. Emphasis describes an artist's attempt (p. 174) to draw our eyes to:
 (a) the Canon
 (b) one area of a composition
 (c) the upper one-third
 (d) the golden section

12. In a work of art, visual rhythm (p. 188) is the result of:
 (a) repetition
 (b) scale
 (c) imbalance
 (d) disruption

13. If one perceives symmetrical balance in an art work (p. 168), this is when:
 (a) two sides are dissimilar
 (b) the eye finds no place to rest
 (c) each side of a composition is exactly the same
 (d) texture is near the fulcrum

14. Scale (p. 180) has to do with:
 (a) dimensions of an art object in relation to the original
 (b) proprieties of royal treatment
 (c) the Maids of Honor
 (d) all of these

15. Design (p. 166) is:
 (a) a process and a product
 (b) a verb and a noun
 (c) the organization of the various elements in an art work
 (d) all of these

Fill-in-the-Blank Questions

16. Frank Gehry re-designed his Santa Monica house (p. 167) in 1976 so that it deliberately lacked _____ .

17. The different types of balance (p. 168) in artistic compositions are symmetrical asymmetrical, and _____.

18. According to your text, one of the most dominant images of _____ in Western art is the crucifix (p. 169).

19. Proportion refers to the relationship (p. 180) between the parts of an object and the _____.

20. To design an art work (p. 166) is to organize its various aspects into a _____.

True False Questions

21. Robert Venturi (p. 191) is a Postmodern architect. T _____ F_____

22. The Las Vegas strip (p. 191) manifests traditional unity and
 pure harmony of a single style. T _____ F_____

23. James Lavadours's works (p. 190) are entirely abstract. T _____ F_____

24. Rodin's *Gates of Hell* (p. 188) is based on Dante's *Divine* Comedy. T _____ F_____

25. Jacob Lawrence's *Barber Shop* (p. 188) captures the rhythm of Harlem life. T _____ F_____

Short Answer Questions

26. William Merrit Chase's *The Nursery* (fig. 234; p. 173) is a good example of what kind of balance?

27. Relative to a small form in an art work (p. 171), we instinctively see something large as what?

28. The illustrated work of Anna Vallayer-Coster (p. 174) employs what kind of color scheme?

29. Marie-Louise-Elizabeth Vigee-Lebrun (p. 175) was the favorite painter of what important 18th century patron?

30. In Georges de la Tour's *Joseph the Carpenter* (fig. 238; p. 175), the light draws our attention away the apparent subject toward what?

Chapter 10 – Drawing

Multiple Choice Questions

1. Raphael's *Saint Paul Rending his Garments* (fig. 274; p. 203) is a metalpoint drawing; this is a medium that requires extreme:
 (a) composition
 (b) skill and patience
 (c) sinopie
 (d) fixative

2. Georgia O'Keeffe's *Banana Flower* (fig. 276; p. 205) shows the work of an artist famous for painted close-ups of flowers, but here is a rare work of:
 (a) silver point
 (b) pure binder
 (c) colorless composition
 (d) cartoon

3. Kathe Kollwitz's *Self-Portrait, Drawing* (fig. 277; p. 205) demonstrates that charcoal has become popular because of its:
 (a) color range
 (b) durability
 (c) erasability
 (d) expressive directness and immediacy

4. George Seurat's *Cafe Concert* (fig. 278; p. 206) is a work in the medium of:
 (a) Conté crayon
 (b) silverpoint
 (c) pastel
 (d) tusche

5. According to Sayre, Jean Dubuffet's *Corps de Dame* (fig. 288; p. 213) can be read as:
 (a) against academic figure drawing
 (b) against the pursuit of formal perfection
 (c) flattening the form
 (d) all of the these

6. Leonardo da Vinci's *Virgin and Child with St. Anne and Infant St. John* (fig. 267; p. 197) is a cartoon; this means it:
 (a) employs wash
 (b) contains colorful comedy
 (c) is a drawing done for a painting
 (d) was produced by a team of collaborators

7. The early studies for Raphael's *The Alba Madonna* (figs. 270, 271; p. 200) show the speed and fluency of its execution, but missing are the:
 (a) legs and arms
 (b) bowls of fruit
 (c) figures
 (d) complex facial expressions

8. Partly because Vija Celmin's pencil drawing of the ocean (fig. 279; p. 206) is so extraordinarily detailed, it is an example of:
 (a) Conte crayon
 (b) photorealism
 (c) expressionism
 (d) charcoal

9. By the end of the 15th century, artists and collectors such as Vasari (p. 191) had come to recognize drawing as the foundation of :
 (a) Renaissance painting
 (b) the Baroque style
 (c) a brilliant biography
 (d) all of these

10. Dry drawing media consist of binders (p. 199), mixed with coloring agents called:
 (a) waxes
 (b) pigments
 (c) grouts
 (d) media

11. A popular drawing medium during the Renaissance consisted of a sharpened point of metal (p. 203) dragged across a prepared ground; the sharpened point was called a:
 (a) crayonizzi
 (b) terazzii
 (c) graphite
 (d) stylus

12. Henri Matisse felt that he could make a line with more feeling than either pencil or charcoal (p. 216) by using:
 (a) crayon
 (b) quill pen
 (c) scissors to cut
 (d) etching needle

13. The technique called wash is when ink is diluted with water (pp. 212-215) and applied by a brush in:
 (a) an elaborate sketch
 (b) broad flat areas
 (c) pastel point
 (d) sinopie

14. Graphite is a form of soft carbon discovered in England in 1564 (p. 206), which became the medium in one of the most common drawing tools known as:
 (a) metalpoint
 (b) charcoal
 (c) Conte
 (d) pencil

15. Beverly Buchanan's drawings and sculptures (pp. 210-211) were inspired by what objects in the rural American South?
 (a) mesa
 (b) hand built shacks
 (c) totem poles
 (d) roadside crucifixes

Fill-in-the-Blank Questions

16. The artist in this chapter thought to have been the most proficient and inventive in pastel (p. 209) was _____ .

17. The two media categories of drawing (p. 199) are liquid media and _____ .

18. The advantage of wet drawing media (p. 212), such as the quill pen and iron gall ink, over dry media is that the wet media is more _____and _____ .

19. The quill pen used by most Renaissance artists for pen and ink drawings (p. 212) was made from a _____ .

20. In order to keep charcoal drawings from smudging (p. 205), today artists apply fixative, which is a _____ .

True False Questions

21. Robert Rauschenburg created a drawing by completely erasing another artist's work (p. 207). T ____ F____

22. Larry Rivers is known (p. 207) for his paper cut-outs drawings. T ____ F____

23. Drawing with a brush is unknown in China (p. 215). T ____ F____

24. Walter De Maria's *Las Vegas Piece* (fig. 293; p. 217) was drawn by a bulldozer blade. T ____ F____

25. David Hockney's *Untitled* (fig. 295; p. 218) electronic sketchpad drawing is childlike because of the limits of the medium. T ____ F____

Short Answer Questions

26. In liquid drawing media (p. 199) the pigments are suspended in what?

27. Rogier van der Weyden's *St. Luke Painting the Virgin and Child* (fig. 273; p. 203) depicts the saint drawing with what medium?

28. In his *Study for a Prophet* (fig. 275; p. 204) Fra Bartolommeo uses what to realize the three-dimensional form of the figure?

29. Who invented Conté crayon (p. 206), and at whose request?

30. With pastels, what determines (p. 208) whether a stick is hard, medium, or soft?

Chapter 11 – Printmaking

Multiple Choice Questions

1. Emile Nolde's *Prophet* (fig. 300; p. 222) illustrates that the German Expressionists used woodcut in the 20th century because they recognized its:
 (a) durability
 (b) impasto-like properties
 (c) expressive potential
 (d) delicacy

2. In *The Races* (fig. 319; p. 235), Edouard Manet uses a favorite printmaking medium of 19th and 20th century artists called lithography, which literally means:
 (a) acacia
 (b) stone writing
 (c) metal plate
 (d) flat surface

3. In the 19th century, the artist of the *Rue Transnonian* (fig. 320; p. 236) was also employed as a famous:
 (a) portrait painter
 (b) politician
 (c) actor
 (d) illustrator and political caricaturist

4. We can see from Durer's *Adam and Eve* (figs. 313; pp. 230-231) that this artist was one of the early masters of:
 (a) intaglio
 (b) planography
 (c) linocuts
 (d) sizing

5. In his *Luncheon on the Grass, after Edouard Manet* (fig. 307; p. 227) Picasso simplified the process by using not wood but:
 (a) lithography
 (b) linocut
 (c) litmus wood
 (d) Albrecht Durer

6. The Japanese print by Utamaro titled *The Fickle Type* (fig. 303; p. 224) represents what is called *ukiyo-e*; this means:
 (a) fragile blossom
 (b) sacred mountain
 (c) pictures of the transient world of everyday life
 (d) imitation of love

7. Jane Dickson's *Stairwell* (fig. 318; p. 234) illustrates the aquatint printmaking process, which relies for its effect not on line but on:
 (a) color
 (b) relief
 (c) tonal areas of light and dark
 (d) extra shiny inks

8. Pop artist Andy Warhol (p. 243) created many art works using silkscreen, which was not originally an art medium but a:
 (a) form of calligraphy
 (b) Renaissance experiment
 (c) monotype
 (d) commercial process

9. A common rubber stamp (p. 222). is a simple example of the printmaking process of:
 (a) relief
 (b) mezzotint
 (c) silkscreen
 (d) burinaglio

10. Registration (p. 227) is the process that assures that the colors of a relief print will do what perfectly?
 (a) edition
 (b) align
 (c) proof
 (d) engrave

11. Lithography is the printmaking process (p. 235) in which the printing surface is completely:
 (a) protruding
 (b) flat
 (c) recessed
 (d) colorless

12. What type of printmaking is unique among the printmaking processes (p. 242) because it produces only one print from the plate?
 (a) serigraphy
 (b) silkscreen
 (c) monotype
 (d) cuneiform

13. In any type of printmaking, after the edition is made (p. 221) the block or plate is:
 (a) inqueated
 (b) unreamed
 (c) exfoliated
 (d) destroyed or canceled

14. Before a zinc or copper plate is placed in an acid bath to be etched (p. 229), it has first been coated with a ground that:
 (a) resists acid
 (b) absorbs the ink
 (c) binds the resin
 (d) captures the lines

15. The print process (p. 228) in which the area that prints is below the surface of the plate is called:
 (a) intaglio
 (b) relief.
 (c) stipplatto
 (d) monotype

Fill-in-the Blank Questions

16. If an artist pushes the point of a burin across a metal plate, it is an intaglio process (p. 229) called _____.

17. Alois Senefelder accidentally discovered (p. 235) the print process of _____.

18. Mezzotint is an intaglio process (p. 234) created by roughing the entire area of a plate with a _____.

19. Relief printmaking (pp. 222-227) includes woodcut, linocut, and _____.

20. Drypoint is an intaglio print process in which the artist draws by _____ a metal-pointed needle (p. 233) across the copper plate surface

True False Questions

21. Anton Koberger (p. 221) was one of the first professional book publishers in history. T _____ F_____

22. Prints were irrelevant (p. 221) to the creation of our shared visual culture. T _____ F_____

23. Japanese woodblock prints (p. 223) were ignored in 19th century Europe. T _____ F_____

24. Van Gogh (p. 223) was most enthusiastic about Japanese prints. T _____ F_____

25. Gauguin's print style (p. 227) emphasized detailed linear representation. T _____ F_____

Short Answer Questions

26. In wood engraving (p. 226), how is extremely delicate modeling achieved?

27. America's first views of the great western canyonlands (p. 226) came from what artist, whose works were copied to wood engravings?

28. The V-shaped metal rod (p. 229) used in engraving is called what?

29. Why did Rembrandt (p. 229) appreciate and employ etching?

30. What tragedy in the life of Kathe Kollwitz may have been foreshadowed by her etching *Death, Woman and Child* (fig. 315; p. 233)?

Chapter 12 – Painting

Multiple Choice Questions

1. In *The Glorification of Saint Ignatius* (fig. 337; p. 251), Fra Andrea Pozzo painted the perspective of this fresco for the Church of Sant'Ignazio in Rome in order to:
 (a) the viewer's eye to Mt. Sinai
 (b) create the illusion that the ceiling had been removed
 (c) transport the soul of the viewer to purgatory
 (d) symbolize Jerusalem

2. Diego Rivera's *Sugar Cane* (fig. 340; p. 254) is an example of the revival of fresco in:
 (a) England round 1835-40
 (b) France in 1789
 (c) Italy in 1740
 (d) Mexico in the 1920's

3. Robert Campin's *The Annunciation Triptych* (fig. 343; p. 256) is referred to as a triptych because it has:
 (a) trompe l'oeil
 (b) attached reliquaries
 (c) three levels of symbolism
 (d) three panels

4. In Winslow Homer's watercolor painting *A Wall, Nassau* (fig. 352; p. 264), both wall and sky are made of washes, that is:
 (a) canvas used as laundry
 (b) thin solutions of pigment and binder media
 (c) pure linseed oil
 (d) diluted printers ink

5. This Egyptian painting (fig. 333; p. 248) *Mummy Portrait of a Man* was created using one of the oldest painting media called encaustic, which is:
 (a) a combination of pigment and hot wax fresco
 (b) pigment and chalk dust
 (c) wet plaster
 (d) egg yolk

6. Andrew Wyeth's *Braids* (fig. 342; p. 255) employs egg tempera; it well illustrates a primary reason for using this medium, which is:
 (a) impasto
 (b) easy color blending
 (c) incredibly fine detail
 (d) all of these

7. A very traditional ground for tempera paintings (p. 254) was gesso, which is:
 (a) sinopie
 (b) Damar varnish and binder
 (c) translucent gouache
 (d) glue and plaster of Paris or chalk

8. In the fifteenth century, oil painting was finally developed (p. 256); it allowed for a blending on the painting surface of:
 (a) continuous scale of hues and tones
 (b) pigment and binder
 (c) tempera and gesso
 (d) gouache and chalk

9. Historically, placing pigments suspended in a medium onto a support (p. 247) has always been:
 (a) the process of painting
 (b) creating an exact likeness of something
 (c) the province of priests
 (d) all of the above

10. A painting process that is so spontaneous (p. 264) that many people think of it as a form of drawing is:
 (a) fresco
 (b) watercolor
 (c) tempera
 (d) encaustic

11. Gouache (p. 266) is a mixture of watercolor pigment and:
 (a) acrylic
 (b) fresco secco
 (c) wine vinegar
 (d) Chinese white chalk

12. Painter Helen Frankenthaler (p. 269) said that something ". . . looks as if it's happened at once." What was she speaking of?
 (a) a happening
 (b) a poem
 (c) a really good picture
 (d) a field painting

13. In 1956, a new paint (p. 269) was developed called acrylic; it is made from the same materials used to make:
 (a) gouache
 (b) wine
 (c) latex paint
 (d) synthetic resin plastics

14. One of the superior aspects of oil paint (pp. 256-263) is its:
 (a) almost instantaneous drying time
 (b) expressive potential
 (c) inability to blend hues and tones
 (d) all of the above

15. Encaustic (p. 248) was widely used in classical Greece and Roman Egypt; even today it is valued for its:
 (a) extraordinary luminosity
 (b) extremely slow drying time
 (c) ease of use
 (d) slaked limewater

Fill-in-the-Blank Questions

16. Mimesis is the term (p. 246) used to describe the concept of _____ .

17. *Trompe l'oeil* occurs when a painting or other artwork looks so real (pp. 258-259) as to _____ itself for reality.

18. Pat Passlof met Willem de Kooning when she attended _____ in 1948.

19. In Susan Rothenberg's *Biker* (fig. 347; p.259), we see that the power of the artist's imagination is embodied in the artist's _____ .

20. In his painting *Untitled* (fig. 354; p. 266) George Baselitz wishes us to value his painting as _____ .

True False Questions

21. Milton Resnick (p. 262) was one of the leaders of the Chicago School. T _____ F_____

22. Watercolor was used by the ancient Egyptians (p. 264) on scrolls. T _____ F_____

23. *Trompe l'oeil* is a French phrase (p. 258) meaning deceit of the mind. T _____ F_____

24. Winslow Homer's watercolor painting style is more expressive than John Marin's (p. 265). T_____ F_____

25. Gouache lends itself (p. 266) to creation of large, flat, colored forms. T_____ F_____

Short Answer Questions

26. Who were the first artists to experiment (p. 267) with synthetic media?

27. What is pyroxylin (p. 267)?

28. Of what does Morris Louis's *Blue Veil* (fig. 357; p. 269) consist?

29. Who or what is AARON (p. 270)?

30. Why are certain painting media (pp. 270-271) better suited to expressive ends than others?

Chapter 13 – Sculpture

Multiple Choice Questions

1. The *Maidens and Stewards* fragment of the Panathenaic Procession from the Parthenon (fig. 363; p. 274) is considered low relief because it:
 (a) is *haut-relief*
 (b) is a frieze
 (c) projects only a little distance
 (d) is modeled

2. The *Pair Statue of Menkaure and His Queen* (fig. 370; p. 278) was carved to bear the *ka* of the deceased into the eternity of the afterlife; the figures are thus:
 (a) kakalypsos
 (b) funerary figures
 (c) sadteros
 (d) urns for ashes

3. Robert Arneson's *Case of Bottles* (fig. 376; p. 282) was created entirely from clay; it illustrates the sculptural process of:
 (a) waxing
 (b) cloying
 (c) grasping
 (d) modeling

4. H. C. Westermann's *Memorial to the Idea of Man If he Was an Idea* (fig. 388; p. 290) is an example of assemblage, which means it is created by:
 (a) compiling objects taken from the environment
 (b) collecting things from under the earth
 (c) poured molten metal
 (d) pieces pasted or welded together

5. According to your author, Eva Hesse's *Contingent* (fig. 392; pp. 292-293) embodies her:
 (a) Korean War experience
 (b) personal strength
 (c) Italian sensibility
 (d) childhood memories

6. The Greek *Kritios Boy* (fig. 371; p. 278) is one of the earliest examples of the principle of ponderation, or:
 (a) chiaroscuro
 (b) perspective
 (c) weight shift
 (d) pose tolerance

7. Michelangelo's unfinished *"Atlas" Slave* (fig. 368; p. 277) shows that he gave up because:
 (a) the block was cracked
 (b) Michelangelo misinterpreted the commission
 (c) the patron refused to pay
 (d) the block resisted transformation

8. Earthworks, such as Nancy Holt's *Sun Tunnels* (fig. 393; p. 294), are:
 (a) large-scale out-of-doors environments
 (b) abstractions of continents
 (c) references to environmental tragedies
 (d) illusions of the earth's core

9. In *Spade with Chains* (fig. 387; p. 289) the artist David Hammons has created an assemblage composed of:
 (a) aluminum figues
 (b) found materials
 (c) recycled forms
 (d) African artifacts

10. As examples of subtractive sculpture, wood and stone (p. 276) are the most common materials for:
 (a) pasting
 (b) modeling
 (c) carving
 (d) casting

11. When a sculpture is created in the additive process (pp. 272-273), the artist:
 (a) pours in hot metal
 (b) collects ordinary objects
 (c) builds up the material
 (d) evaporates the residue

12. One aspect of wood carving (p. 276) a sculptor pays attention to is working with the grain; to work "against the grain" is to:
 (a) install a piece
 (b) ignore the wood's additive qualities
 (c) create an additive work
 (d) risk destroying the block

13. Firing pliable clay holds its form permanently (pp. 282-283); firing means:
 (a) baking at extremely high temperatures
 (b) casting in fiery bronze
 (c) carving with flame thrower
 (d) soaking it

14. Among the different types of sculpture, an environment (p. 276) is a sculptural space that you can physically:
 (a) mourn
 (b) enter
 (c) dig
 (d) hear

15. By the late fourteenth century CE, brass casting had reached a high revel of refinement (p. 285) in:
 (a) Etruscan towns
 (b) Rome
 (c) the African Kingdom of Benin
 (d) Papal tombs

Fill-in-the-Blank Questions

16. Naturalism in Greek sculpture (p. 278) was in part the result of anatomical investigations in the field of _____ .

17. According to the author, the two basic processes (p. 272) employed by sculptors are either _____ and _____.

18. An installation (p. 276) is an environment that is set up or situated _____.

19. The sculptural method (p. 284) first discovered during the Bronze Age (c. 2500 BCE), used to make various utensils, is called _____ .

20. Although Greek sculpture contributed much to naturalism (p. 278) in western figurative sculpture, their early styles are indebted to _____ sculpture.

True False Questions

21. During the bronze casting process, the space inside the wax lining is filled (p. 287) with an investment. T _____ F_____

22. The force that fully activates Walter de Maria's *Lightning Field* (p. 295) is thunderstorms. T _____ F_____

23. Nancy Holt's *Sun Tunnels* (fig. 393; 294-295) is an underground earthwork T _____ F_____

24. In 1960 Anthony Caro (p. 297) was heavily influenced by Karen McCoy. T _____ F_____

25. The sculptor Eva Hesse (p. 292) was a longtime feminist. T _____ F_____

Short Answer Questions

26. Nancy Holt says that *Sun Tunnels* (p. 295) is part of an area of the world where one can see the curvature of the earth, which evokes what?

27. During the making of *Contingent* (fig. 392; p. 293) what did Eva Hesse write that she learned?

28. How does Walter de Maria want visitors to the environment of *Lightning Field* (p. 295) to experience the space?

29. Clyde Connell's assemblage *Swamp Ritual* (fig. 389; p. 291) is made of what?

30. Seeing the use of drapery in classical sculpture during a visit to Greece in 1951 (p. 284), Henry Moore was encouraged to use drapery to emphasize what?

Chapter 14 – Other Three-Dimensional Media

Multiple Choice Questions

1. The *Unicorn in Captivity* (fig. 414; p. 308) is a special type of weaving, in which the weft
 yarns are of several colors and the weaver manipulates the colors to make a design, called a:
 (a) embroidery
 (b) tapestry
 (c) collage
 (d) warpage

2. Robert Rauschenberg's *Monogram* (fig. 425; p. 316) is part sculpture and part painting, and is
 often referred to as a combine-painting or:
 (a) montage
 (b) happening
 (c) high-relief collage
 (d) happening

3. Magdalena Abakanowicz's *Backs in Landscape* (fig. 417; p. 310) is by an artist who helped
 transform what craft medium into a fine art?
 (a) quilting
 (b) embroidery
 (c) ceramics
 (d) fibers

4. Jackson Pollock's *Full Fathom Five* (fig. 431; pp. 318-319) is one example of a type of
 painting by Pollack that inspired Allan Kaprow to invent Happenings, because of the
 painting's
 (a) inclusiveness
 (b) flexibility
 (c) installation
 (d) construction

5. Hon'ami Koetsu's *Amagumo* tea bowl (fig. 402; p. 301) was made at one of the "Six Ancient
 Kilns," the traditional centers of wood-fired ceramics in Japan; these early kilns were known
 as:
 (a) kabuki
 (b) raku
 (c) ugetsu
 (d) anagama

6. As seen in her 1926 tapestry of varied but controlled rectangular forms (fig. 416; p. 309),
 Anni Albers regarded geometric play as rooted in:
 (a) the psyche
 (b) poetry

(c) nature

(d) chaos theory

7. Pliable clay is made to hold its form permanently (p. 300) by firing it in a:
 (a) contingent
 (b) kiln
 (c) bronze bath
 (d) slabbery

8. Native Americans used a traditional method for producing pots (p. 301) called coiling that:
 (a) did not involve a potter's wheel
 (b) used clay in long rope-like strands
 (c) involves smoothing as a step
 (d) all of these

9. All fiber arts evolved from weaving, the traditional process (p. 308) of:
 (a) interlacing horizontal and vertical threads
 (b) needle stitching
 (c) embroidery
 (d) tanning hides

10. Originally, when an individual produced functional objects by expert handiwork (p. 300), we would have said they worked in:
 (a) a bronze foundry
 (b) a factory
 (c) a garret
 (d) the crafts

11. All ceramic art objects are created (pp. 300-305) by:
 (a) throwing
 (b) slab construction
 (c) coiling
 (d) all of these

12. In the twentieth century artists have created works of art referred to as being in mixed media (p. 313); this means the works:
 (a) will never harden
 (b) combine different media
 (c) have no durability
 (d) are purely functional

13. Judy Pfaff's *Rock/Paper/Scissors* (fig. 428; p. 317) is an example of how collage has begun to move into or spilled out into the space of the room; it thus exemplifies the medium of:
 (a) ceramics
 (b) installation
 (c) glass blowing
 (d) theater

14. Allan Kaprow created Happenings (p. 318), or works that are:
 (a) found object performance
 (b) multiplicities
 (c) assemblages of events performed in more than one time and place
 (d) combine-theater

15. Goat Island's *How Dear to Me the Hour When Daylight Dies* (figs. 436,437; p. 322),
 demonstrates that the artists use their bodies as media, which is a primary characteristic of:
 (a) performance art
 (b) combine-sculpture
 (c) installation
 (d) collage

Fill-in-the-Blank Questions

16. Collage is the process (p. 313) of gluing or pasting fragments of printed matter, fabric and
 other flat material onto a _____ .

17. Typically, a ceramic object is painted with a glaze (p. 300) to give it a _____
 _____after firing.

18. The three basic types (p. 303) of ceramics (clay bodies) are earthenware, _____,
 and_____.

19. "Glassblowing" has its origins in the first century B.C.E. (p. 306), and is thought to have
 been developed by the _____.

20. Originally,_____ was the primary market for the distinctive blue-and-white pattern
 of Ming porcelain.

True False Questions

21. By the time of the Ming Dynasty in China, the official kilns at
 Chingtehchen (p. 303) were small one-person workshops. T _____ F_____

22. The *anagama* or wood-burning kiln process involves accidental
 effects (p. 304) and takes seven days. T _____ F_____

23. The potter's wheel is a bowl-shaped device(p. 302) into which
 one pours liquid clay for centrifugal forming into a throwing mold. T _____ F_____

24. A Greek amphora (p. 302) is a two-handled vase. T _____ F_____

25. Before his ceramics pieces are dry, Peter Voulkos (p. 404) gouges them. T _____ F_____

Short Answer Questions

26. What is the primary formal motive (p. 313) for doing collage?

27. What was thought to be the primary catalyst (p. 321) for the *Fluxus* group?

28. Why does Peter Voulkos use the "x" as a reference (p. 305) to the *shoshin*?

29. According to your author, why does Peter Voulkos (p. 305) utilize the pyramid form?

30. Dale Chihuly's work (pp. 306-307) demonstrates what other quality of glass, beyond the interplay of line and space?

Chapter 15 – The Camera Arts

Multiple Choice Questions

1. In Louis Daguerre's *Le Boulevard du Temple* (fig. 445; p. 329) there is only one figure visible because imprinting the image took:
 (a) place only late at night
 (b) all the photographer's patience
 (c) 8-10 minutes
 (d) so much money only the wealthy could afford it

2. Margaret Bourke-White's *At the Time of the Louisville Flood* (fig. 455; p. 336) was shot while she was on assignment for:
 (a) the State Department
 (b) *Life* magazine
 (c) the FBI
 (d) Alfred Steiglitz

3. In the words of Joel Meyerowitz, as indicated in his *Porch, Provincetown* (fig. 458; p. 338), color in photography allows more:
 (a) size
 (b) speed
 (c) fun
 (d) content

4. In Sergei Eisenstein's *Battleship Potemkin* (fig. 463; p. 341) we see the editing technique of sequencing widely disparate images known as:
 (a) montage
 (b) frottage
 (c) collage
 (d) brakhage

5. As seen in *TV Buddha* (fig. 471; p. 346) Nam June Paik is best known for expanding the traditional limitations of artistic media by creating video:
 (a) commercials
 (b) installations
 (c) movies
 (d) cartoons

6. Fernand Léger's *Ballet Mécanique,* with its juxtaposition of objects and pure shapes (fig. 461; p. 340), demonstrates that the process of editing is a sort of:
 (a) surrealist nightmare
 (b) super-realist hallucination
 (c) zoopraxiscope
 (d) linear collage

7. The *camera obscura* was invented in the 16th century (p. 328) as a means of capturing and fixing images from the natural world; the name means:
 (a) film noir
 (b) chamber of truth
 (c) dark room
 (d) blurry box

8. Despite the success of the daguerreotype, it had some real disadvantages (p. 330), including:
 (a) the image could not be reproduced
 (b) the plate had to be kept in darkness
 (c) it took time to prepare
 (d) all of these

9. In 1850 the British sculptor Frederick Archer (p. 331) introduced a great advance in photography called:
 (a) enlargement
 (b) wet-plate collodian
 (c) celluloid
 (d) the photogenic box

10. The drama in Andy Warhol's film *Empire* (fig. 464; p. 342) lies in the:
 (a) audience's reaction to the monotonous image
 (b) poetry of juxtaposition
 (c) rapid sequencing of shots
 (d) animalistic behavior of the actors

11. Nam June Paik's *TV Bra for Living Sculpture* (fig. 472; pp. 346-347) attempted to literally realize:
 (a) trashy films of Dollywood
 (b) a careful political statement
 (c) musical embarrassment
 (d) humorous wordplay

12. In 1927 sound was introduced into film (pp. 342-343) in a feature called:
 (a) *The Gold Rush*
 (b) *The General*
 (c) *The Jazz Singer*
 (d) *The Navigator*

13. In The first great master of film editing (p. 340) was D.W. Griffith who, in *The Birth of a Nation*, essentially invented the standard:
 (a) moving picture
 (b) 35 mm frame
 (c) tripod
 (d) vocabulary of filmmaking

14. In filmmaking, a shot (p. 340) is a:
 (a) continuous sequence of film frames
 (b) wide expanse of many characters
 (c) joining of disparate images
 (d) rolling cart for the camera

15. Released in 1941, *Citizen Kane* was a masterful work (p. 343), and the first American film to fully utilize:
 (a) saturated color overlays
 (b) every known trick of the filmmaker's trade
 (c) real recorded sounds
 (d) stop-action animation

Fill-in-the-Blank Questions

16. William Henry Fox called his process (p. 329) for fixing negative images on paper coated with light-sensitive chemicals_____.

17. Editing is the process (p. 340) of arranging the_____of a film after it has been shot in its entirety.

18. Russian filmmaker Sergei Eisenstein invented montage (p. 341), which is editing to sequence widely_____ to create a fast-paced multifaceted image.

19. According to artist Robert Rauschenberg (p. 328) photography is a process of instant _____ _____or instant _____.

20. In film, the_____ shot (p. 341) is when the camera moves back to front or front to back.

True False Questions

21. After seeing his first daguerreotype, the French painter (p. 330) Edouard Manet is reported to have said "Painting is dead."　　　T _____ F_____

22. In 1862 the French government (p. 332) gave photography the legal status of art.　　　T _____ F_____

23. The basis of modern photography (p. 330) is the calotype.　　　T _____ F_____

24. The first book of photographs (p. 331) was produced by Fred Archer and called *The Imitation of Reality*.　　　T _____ F_____

25. According to Sayre, digital technologies (p. 339) have rendered film obsolete.　　　T _____ F_____

Short Answer Questions

26. Andy Warhol's 1964 film titled *Empire* (p. 342) is the visual equivalent of what musical piece?

27. What has video artist William Wegman (p. 347) investigated in a number of short videos?

28. What does Bill Viola's *Stations* (fig. 478; p.350) strip away?

29. To what does the title of Gary Hill's *Crux* (fig. 479; p. 351) refer?

30. What separates the *art* of photography, film, and video (p. 352) from mainstream commercial film or television production?

Chapter 16 – Architecture

Multiple Choice Questions

1. The form of the pyramids of Menkaure, Khafre, and Khufu (fig. 486; p. 357) is probably derived from the rays of the sun descending to earth, and thus relates to the image of:
 (a) Anasazi
 (b) the god Re
 (c) Isis
 (d) Akenhaten

2. The Pont du Gard near Nimes in France (fig. 495; p. 362) used arch construction to carry water from the distant hills to the Roman compound; it is therefore an:
 (a) architrave
 (b) stylobate
 (c) entablature
 (d) aqueduct

3. The Pantheon in Rome (fig. 499; p. 364) was a temple; its name means:
 (a) house of holies
 (b) treasury
 (c) every god
 (d) sacred mountain

4. As an example of a Gothic cathedral, at Notre Dame in Paris (fig. 505; p. 366) we see:
 (a) flying buttresses
 (b) round arches
 (c) colonnades
 (d) post-and-lintels

5. Frank Lloyd Wright's Robie House (fig. 518; p. 372) is the most notable example of his:
 (a) sculptural style
 (b) expressionist style
 (c) machine-age style
 (d) Prairie House

6. Mies van der Rohe's and Philip Johnson's Seagram Building (fig. 524; p. 375) is typical of the International Style in its:
 (a) graceful curves
 (b) austere geometric simplicity
 (c) ornamental spirit
 (d) sinister urban conditions

7. The Anasazi Cliffside caves at Mesa Verde (fig. 488; p. 358) show the roofs of two kivas; these are the:
 (a) foothills leading up to the mountains
 (b) lintel stones for cliff apartments
 (c) fluting on the columns
 (d) underground spaces for ceremonial life

8. In the construction of the Egyptian pyramids (p. 359), the builders made the walls load-bearing; this means that:
 (a) arcades span the spaces
 (b) trusses suspend the ceiling
 (c) walls carry the roof's weight
 (d) a skeleton raises up a skin

9. The "look" of a culture's buildings and communities (p. 356) depends on the distinct landscape characteristics of the site, and the:
 (a) money and time
 (b) available materials and methods
 (c) patron's desires
 (d) assuaging of the gods

10. The Romans were able to create large, uninterrupted interior spaces in architecture (p. 363) because of the development of the:
 (a) barrel vault
 (b) elastic stone lintel
 (c) frieze and cornice
 (d) skeleton and steel construction

11. In the Gothic period when Notre Dame de Paris was built (p. 366), the use of the pointed arch allowed the great height of the cathedral's:
 (a) cast iron covering
 (b) platform
 (c) interior space
 (d) dome

12. Gothic architects used flying buttresses (p. 366) to compensate for the:
 (a) staggering system of lintels
 (b) massive colonnade
 (c) heavy infilling of the walls
 (d) lateral thrust of the interior

13. The Romans (p. 362) realized that, as opposed to post-and-lintel construction, the arch would allow them to make structures with:
 (a) greater durability
 (b) a much larger span
 (c) better taste
 (d) more religious zeal

14. The Eiffel Tower was the centerpiece for the 1889 Paris Exposition (p. 367), and is made of:
 (a) glass and steel
 (b) limestone beams
 (c) cast iron
 (d) masonry construction

15. Frederick Olmsted conceived of the suburb (p. 382), that is a residential community outside the city but within:
 (a) commuting distance
 (b) the city park
 (c) the great central orb
 (d) the apartment complex

Fill-in-the-Blank Questions

16. In the Prairie House style of Frank Lloyd Wright (p. 372), the horizontal sweep of the roof reflects the flat expanses of the _____.

17. High tensile strength allows a material to span a large horizontal distance (p. 359) without support or_____.

18. The shell system and the skeleton-and-skin system (p. 359) are the two basic _____ _____ of walls utilized by buildings?

19. The three Greek architectural orders (p. 361) are the Doric, the_____ , and the _____ _____.

20. The dramatic tapering of a column (p. 360) at the top and slight tapering at the bottom is known as _____.

True False Questions

21. All columns (p. 360) are made of a single piece of stone. T _____ F_____

22. Arch construction is fundamental to Greek architecture (p. 360). T _____ F_____

23. An arch is made of wedge-shaped stones (p. 362) called *voussoirs*. T _____ F_____

24. The barrel vault at St. Sernin in Toulouse (fig. 501; p. 365) is a magnificent example of Romanesque architecture. T _____ F_____

25. For Louis Sullivan the foremost problem of the modern architect (p. 370) was how to transcend the overly pleasant conditions of the suburb. T _____ F_____

Short Answer Questions

26. Why is balloon-frame construction (p. 368) called this?

27. From the outset, the bungalow was conceived as what?

28. As seen in the Marshall Field Warehouse Store (fig. 514; p. 370), H.H. Richardson's genius lay in what?

29. Mies van der Rohe's Farnsworth House (fig. 523; pp. 374-375) references what other buildings?

30. Eero Saarinen's TWA Terminal (figs. 526, 527; p. 376) is defined by what contrast?

Chapter 17 – Design

Multiple Choice Questions

1. Antoni Gaudi's *Sagrada Familia* (fig. 559; p. 397) is a twisting, spiraling, almost fluid mass of forms; it thus incorporates what primary qualities of Art Nouveau?
 - (a) geometric cubic
 - (b) symmetrically balanced
 - (c) abstract realistic
 - (d) organic curvilinear

2. Joseph Paxton's *Crystal Palace* (fig. 546; p. 391) could be considered an early example of the relationship between new technology and architecture, because it hailed in a new age of:
 - (a) handcrafted decoration
 - (b) elegant ornament
 - (c) prefabricated construction
 - (d) organic unity

3. The qualities of a work like Louis Comfort Tiffany's *Water-lily Table Lamp* (fig. 556; p. 396) inspired the new style of Art Nouveau as:
 - (a) design movement:
 - (b) use of electricity
 - (c) mode of pure painting
 - (d) socialist sculpture

4. Gerrit Rietveld's *Red and Blue Chair* (fig. 567; p. 401) employs the De Stijl vocabulary of:
 - (a) primary colors
 - (b) black and white
 - (c) vertical and horizontal grid
 - (d) all of these

5. Eames's *DCM Sidechair* (fig. 581; p. 409) demonstrates the more curvilinear design style of the 1940's and 1950's, and employs:
 - (a) streamlined iron
 - (b) molded plywood
 - (c) unipod plastic
 - (d) waterflow chromium

6. In his design for the catalogue cover (fig. 570; p.402) for the Russian exhibit at the 1925 Paris Exposition, Russian Constructivist Aleksander Rodchenko used:
 - (a) handcrafted decoration
 - (b) the serif and biomorphic
 - (c) geometrical simplification
 - (d) organic curvilinear

7. The Bauhaus (p. 405) stressed that there was no difference between:
 (a) the fine arts and the crafts
 (b) organic and geometric
 (c) the curvilinear and the perpendicular
 (d) purist and geometricist

8. Josiah Wedgwood was famous (p. 389) for creating two kinds of pottery ware, which are:
 (a) geometric and organic
 (b) green and orange
 (c) ornamental and useful
 (d) Greek and Roman

9. Siegfried Bing was among the first promoters of an art form (pp. 396-397) that used:
 (a) anything organic and undulating
 (b) willow tree forms
 (c) vines or women's hair
 (d) all of these

10. The Dutch art group known as De Stijl (p. 401) took its lead from the painting of Braque and Picasso, in which elements of the real world were simplified into:
 (a) pastel palette
 (b) a vocabulary of geometric forms
 (c) cubic shards of space
 (d) asymmetrical ornament

11. Wedgwood's two different types of pottery clearly illustrate how the art of design has traditionally differentiated between:
 (a) decorative and basic
 (b) geometric and ornamental
 (c) crafts and fine arts
 (d) elegant and functional

12. William Morris is regarded as the father of The Arts and Crafts Movement (pp. 391-394) in England, which emphasized:
 (a) handmade craft tradition
 (b) simplicity and utility
 (c) the natural and organic
 (d) all of these

13. One of the most successful American industrial designers re-designed the Coca Cola bottle (fig. 588; p. 414) in 1957; his name was:
 (a) Eero Saarinen
 (b) Raymond Loewy
 (c) Mies van der Rohe
 (d) Ray Eames

14. The Swiss design team of Robert and Durrer conceive of the design identity of the Swatch watch (fig, 589; p. 414) as:
 (a) constant and immortal
 (b) kinetic and ever-changing
 (c) streamlined and essential
 (d) organic and natural

15. The fins on the 1948 Cadillac (p. 410) were design by Harley Earl as an:
 (a) aerodynamic symbol
 (b) expression of purest beauty
 (c) embodiment of geometric abstraction
 (d) organic statement of capitalism

Fill-in-the-Blank Questions

16. Josiah Wedgwood's cream-colored, useful earthenware (p. 390) was dubbed_____ _____.

17. Since 1968, the style of *Art Moderne* (p. 399) has been better known as _____

18. By the turn of the century Frank Lloyd Wright felt compelled to design furniture (p. 394) to match the interiors of his houses, following the example of _____ _____.

19. In 1934 streamlining, whereby airflow drag is dramatically reduced, was publicly embodied in the form of a train (fig. 575; p. 406) called the _____ .

20. Fred Wilson (pp. 412-413) is a _____who exposes the cultural, political, and socioeconomic assumptions that underlie the modern museum space.

True False Questions

21. Russel Wright's American Modern dinnerware (fig. 578; p. 408) shows
 that streamlining captures the European heritage of the design. T _____ F_____

22. In the history of design, by the late 1930's (p. 408) in order to be modern
 a thing had to be streamlined. T _____ F_____

23. By the late 1950's the excess of the Cadillac defined American style
 in design. T _____ F_____

24. In his *Tulip Pedestal Furniture* of the 1950's (fig. 582; p. 410), Eero
 Saarinen had originally planned to make the chairs out of stainless steel. T _____ F_____

25. One characteristic of postmodern design is a willingness to
 incorporate collisions of competing cultures. T _____ F_____

Short Answer Questions

26. According to the Russian Constructivists (p. 402), where should artists working in the new post-revolutionary state go?

27. On what does the aesthetic appeal of Gustav Stickley's furniture (fig. 553; p. 394) depend?

28. In El Lissitzky's *Beat the Whites with the Red Wedge* (fig. 569; p. 402), the red wedge and the white circle symbolized what?

29. In 1920 in *L'Esprit Nouveau*, Le Corbusier (p. 400) wrote that "decorative art, as opposed to the machine phenomenon" was the final twitch of what?

30. Gerrit Rietveld's design of the upper floor interior of the Schröder House (p. 401) is meant to immerse its occupants in what?

Chapter 18 – The Ancient World

Multiple Choice Questions

1. The drawings of *Horses* (fig. 596; p. 419) at Chauvet Cave in the Ardeche Gorge suggest that prehistoric people possessed:
 (a) portable altars for worship
 (b) primitive weapons for killing
 (c) the same level of skill as anyone ever has
 (d) only rudimentary intelligence

2. The *Worshippers and Deities* from the Abu Temple (fig. 600; p. 421) are Sumerian figures; the tallest is Abu who is the god of:
 (a) river water
 (b) vegetation
 (c) lightning
 (d) sandstorms

3. The *Nike of Samothrace* (fig. 613; p. 431) is an excellent example of Hellenistic realism because of the figure's:
 (a) idealized proportions
 (b) relaxed grace
 (c) increased animation and drama
 (d) canon of proportions

4. The *Column of Trajan* (fig. 620; p. 434), encircled by a spiraling band of relief sculpture detailing the reign of Emperor Trajan, is a remarkable symbol of Roman:
 (a) wealth
 (b) architectural prowess
 (c) patriotism
 (d) power

5. *The Great Stupa* (fig. 623; p. 437) is one of the earliest surviving examples of a *stupa* or burial mound, and houses the relics of:
 (a) Buddha
 (b) Krishna
 (c) Vishnu
 (d) Asoka

6. The *Palette of King Narmer* (fig. 603; p. 424) utilizes a canon of:
 (a) hieroglyphic scale
 (b) ideal proportions
 (c) proper colors
 (d) higher order symbolism

7. The *"Toreador" Fresco* (fig. 608; pp. 426-427) was from the Minoan culture, and depicts:
 (a) a bullfight in southern Italy
 (b) Romans encircling a herd of bulls
 (c) Knossos stabbing the bull with a sword
 (d) a youth vaulting over the bull's back

8. Found near Willendorf, Austria, the *Venus of Willendorf* (fig. 595; p. 419) is most likely a fertility figure, judging from its:
 (a) exaggerated belly
 (b) lack of facial features
 (c) exaggerated breasts
 (d) all of these

9. The New Stone Age (p. 419) is referred to by the term:
 (a) Paleolithic
 (b) Neolithic
 (c) Lithography
 (d) Novoclopean

10. Egyptian culture was dedicated to providing a home for the *ka* (p. 423), which is the:
 (a) enduring spirit
 (b) part of the human being that defines personality
 (c) part of the human that survives after death
 (d) all of these

11. Neolithic society (p. 421) developed quickly in what parts of the world?
 (a) fertile river valleys
 (b) equatorial jungles
 (c) deserts
 (d) dense hilly forests

12. The discovery of Tutankhamen's tomb in 1922 greatly increased our knowledge about the freer, more naturalistic period of Egyptian art (p. 425) that was initiated by Emperor:
 (a) Ramses
 (b) Khafre
 (c) Akhenaten
 (d) Narmer

13. Reaching its peak between 1600-1400 B.C.E., the Minoan civilization (p. 426) was situated on the island of:
 (a) Minos
 (b) Malta
 (c) Peloponnos
 (d) Crete

14. The huge, intricate designs of the Minoan royal palaces (p. 426) probably gave rise to the:
 (a) myth of Hercules
 (b) legend of the labyrinth of the Minotaur

(c) stories of King Midas

(d) Trojan War

15. Mycenaean burial chambers (p. 427) are referred to as beehive tombs, and contained:
 (a) gold masks of the royal dead
 (b) catacombs
 (c) Greek crosses
 (d) Egyptian palettes

Fill-in-the-Blank Questions

16. Begun in 450 B.C.E under the leadership of Pericles, the Acropolis in Athens (p. 428) is the crowning achievement of _____.

17. A people that adopted the art and architectural styles of the Greeks, but also inherited cultural influence (p. 432) from the Etruscans were the _____.

18. According to Buddhism, nirvana is the state of _____ after the release from worldly desires (p. 436) ending the cycle of death and reincarnation.

19. An early Mesopotamian text (p. 422) refers to the zigurrat as the bond between _____ _____.

20. Based on the words for "people" and "power," the term (p. 428) used to describe the Athenian Greek's political system is _____.

True False Questions

21. In Minoan culture (p. 426), the crow held sacred significance. T_____ F_____

22. The Mycenaeans (p. 427) were pacifists and often taken as slaves. T_____ F_____

23. One of the most important subjects in Greek art (p. 428) is the human figure. T_____ F_____

24. The Athenian democracy (p. 426) allowed everyone to vote. T_____ F_____

25. Athena Parthenos (p. 429) was the Greek goddess of wisdom. T_____ F_____

Short Answer Questions

26. Even after the disastrous defeat of the Athenians in the Peloponnesian War, the Greeks had an evident passion for what?

27. Why did Hellenism (p. 430) come to dominate the Western World?

28. Why is the *Palette of King Narmer* (fig, 603; p. 424) called a "palette"?

29. The hemispherical dome of the Great Stupa at Sanchi (fig. 623; p. 437) symbolizes what?

30. The *Ritual Disc with Dragon Motif* (fig. 622; p. 436) symbolized what desire on the part of the Chinese?

Chapter 19 – The Christian Era

Multiple Choice Questions

1. San Vitale in Ravenna (fig. 626; p. 440) was conceived as a political and religious statement; it was built by:
 (a) the Huns
 (b) Saint Costanza
 (c) Justinian
 (d) Pagan Romans

2. *Theodora and her Attendants* (fig. 627; p. 441) is a mosaic, and therefore is made of small pieces of stone called:
 (a) frescoids
 (b) tesserae
 (c) temperalis
 (d) mossaccio

3. Hagia Sophia (fig. 629; p. 442) was Justinian's imperial place of worship in Constantinople; the name means:
 (a) Hail to Youth
 (b) Sacred Mountain
 (c) Great Dome
 (d) Holy Wisdom

4. The *Hinged Clasp* from the Sutton Hoo burial ship (fig. 632; p. 445) illustrates the animal style of Celtic design by:
 (a) being elaborately decorative
 (b) containing no naturalistic representation
 (c) being highly abstract
 (d) all of these

5. Chartres Cathedral (fig. 639; p. 448) is an excellent example of what style of architecture?
 (a) Gothic
 (b) Romanesque
 (c) Carolingian
 (d) Byzantine

6. Kandariya Mahadeva Temple at Khajuraho, India (fig. 648; p. 453) was completed just before the great Romanesque cathedrals of Europe; it symbolically captures the:
 (a) enemies of the Vishnu
 (b) rhythms of the cosmos
 (c) worshippers of darkness
 (d) all of the above

7. This *St. Matthew* page from the Gospel Book of Charlemagne (fig. 634; p. 446) is an excellent example of Carolingian art, and demonstrates the impact upon Northern art of:
 (a) Gothic art
 (b) Roman realism
 (c) Islamic
 (d) Hindu

8. The single tower of the mosque at Samarra, Iraq (fig. 645; p. 452) is called a:
 (a) mithras
 (b) caliph
 (c) minaret
 (d) madras

9. The first Christian churches were rectangular and patterned after Roman public buildings (p. 439), especially courthouses; these are called:
 (a) basilicas
 (b) bathrubs
 (c) palazzi
 (d) constantinos

10. The first large sculpture since Roman times (p. 447) can be found in Romanesque churches in a semicircular arch above the lintel of the main door, called the:
 (a) acanthus
 (b) mihrab
 (c) mandorla
 (d) tympanum

11. Gothic architecture (p. 448) began in 1137 under the desire of Abbot Suger of St. Denis for more:
 (a) massive walls
 (b) light
 (c) wooden doors
 (d) lintel sculpture

12. By 500 C.E. most of the western empire had been overrun by barbarian tribes (pp. 439-440); Justinian attempted retook the Mediterranean world from these tribes from:
 (a) Africa
 (b) Iceland
 (c) northern Europe
 (d) the middle east

13. At Hagia Sophia (pp. 442-443) four pendentives are used to support:
 (a) the brick walls
 (b) four lintels
 (c) tesserae
 (d) the dome

14. In Romanesque architecture, flat ceilings (p. 446) were replaced with vaulted ceilings, which had to be supported by:
 (a) domes
 (b) flying buttresses
 (c) pendentives
 (d) massive walls

15. The Christian manuscripts produced in Ireland (pp. 444-445) incorporated the animal style, which reflects native:
 (a) Celtic designs
 (b) representational naturalism
 (c) accurate perspective
 (d) mosaic

Fill-in-the-Blank Questions

16. Charlemagne (p. 446) was intent on restoring the _____ of Roman civilization.

17. Made possible by the inventive use of flying buttresses, Gothic churches (p. 449) contained extremely _____.

18. The art of India was affected greatly by Aryan tribesmen (p. 453) who invaded the area as early as 1500 BCE. They wrote *Vedas*, which were their_____.

19. The mosque (p. 452) was the major architectural form of _____.

20. In 313 C.E. in the Edict of Milan (p. 439), Emperor Constantine legalized _____.

True False Questions

21. Lost since the decline of Byzantium, the Romanesque period (p. 447) marked the return of the art of mosaic. T _____ F_____

22. Under Charlemagne (p. 446), the fusion of Germanic and Mediterranean styles in art is called Carolingian art. T _____ F_____

23. The original St Peter's in Rome (p. 439) was a circular mausoleum. T _____ F_____

24. At Santa Costanza (fig. 625; p. 439), surrounding the circular space is an ambulatory used for processions. T _____ F_____

25. Sant' Apollinare in Classe (p. 439) employs wooden trusses to support the roof. T _____ F_____

Short Answer Questions

26. What happened to Christian art (p. 439) in C.E. 313?

27. According to your author, all Muslim design (p. 453) is characterized by what?

28. How is the sculpture of the Gothic cathedral (pp. 450-451) different from that of the Romanesque cathedral?

29. Who was finally halted in their northward advance into Europe (p. 452) by the grandfather of Charlemagne in C.E. 732?

30. At a mosque (p. 452), what does the *mihrab* symbolize?

Chapter 20 – The Renaissance Through The Baroque

Multiple Choice Questions

1. Donatello's *David* (fig. 650; pp. 456-457) is the first life size nude sculpture since:
 (a) Gislebertus
 (b) the Romanesque
 (c) antiquity
 (d) the Carolingian period

2. In Sandro Botticelli's *The Birth of Venus* (fig. 654; p. 459) we see that the artist used mythological themes to transform his pagan imagery into a source of:
 (a) barbarism
 (b) anatomical idealism
 (c) Hellenism
 (d) Christian inspiration

3. Leonardo da Vinci's *Mona Lisa* (fig. 656; p. 461) fascinates viewers even today because it conveys:
 (a) divine frenzy
 (b) psychological depth
 (c) pagan imagery
 (d) perfect atmospheric perspective

4. Raphael's *School of Athens* (fig. 657; pp. 462-463) depicts a gathering of:
 (a) the greatest ancient philosophers and scientists
 (b) a Christian tribunal
 (c) Roman architects
 (d) the greatest Renaissance humanists

5. Wu Chen's *Bamboo* (fig. 662; p. 465) included a political symbol that China would bend but not break; it was aimed at:
 (a) the Ming dynasty
 (b) calligraphy
 (c) China's Mongol rulers
 (d) the sky

6. The sculptor Bernini created *The Ecstasy of St. Theresa* (fig. 674; p. 471) as the centerpiece of a chapel in Rome; it is typical of the Baroque because of its
 (a) restraint and calm
 (b) linear perspective
 (c) classicism
 (d) drama and theatricality

7. *Coatlicue* (fig. 666; p. 467) was the Aztec goddess of:
 (a) vegetation
 (b) life and death
 (c) health and prosperity
 (d) the fertile earth

8. Leonardo da Vinci offered his services to the Duke of Milan (pp. 460-461) only secondarily as an artist; his first role to the Duke was as:
 (a) scribe
 (b) architect
 (c) military engineer
 (d) secretary

9. The scene from the Limbourg Brothers' manuscript *Les Tres Riches Heures du Duc de Berry* (fig. 649; p. 455) is full of:
 (a) realistic detail
 (b) chiaroscuro
 (c) heavenly figures
 (d) Neo-Platonism

10. In the 1330s, Petrarch had conceived of a new Humanism, that is a philosophy (p. 455) that emphasized:
 (a) Gothic barbarism
 (b) the fine arts
 (c) the medical arts
 (d) the unique value of each person

11. Under the leadership of the Medici family (p. 456), the cultural center of the early Renaissance was:
 (a) Sforza
 (b) Florence
 (c) Milan
 (d) Vinci

12. Based on the Greek and Roman statuary he saw in Rome, Donatello's *David* (fig. 650; pp. 456-457) is posed in:
 (a) the midst of a battle
 (b) dramatic action
 (c) contrapposto
 (d) progressive movement

13. By their commitment to rendering believable space in realistic detail, Northern Renaissance artists (p. 458) are distinguished from:
 (a) artists of the Italian Renaissance
 (b) English artists
 (c) artists of the Rococo
 (d) Byzantine artists

14. Many art historians consider Leonardo da Vinci's *The Last Supper* (p. 461) to be the first:
 (a) work of military engineering
 (b) true Italian oil painting
 (c) use of linear perspective
 (d) High Renaissance painting

15. The Chinese valued landscape painting as the second highest form (p. 465) of artistic endeavor; to them the first was:
 (a) architecture
 (b) calligraphy
 (c) portraiture
 (d) religious sculpture

Fill-in-the-Blank Questions

16. The cultures of the Pre-Columbian peoples (p. 466) are distinguished by their monumental architecture and by their preference for working _____ .

17. Mayan civilization (p. 467) reached its peak in_____ and _____ around C.E. 250, just after the rise of Teotihuacán.

18. Michelangelo's fresco painting of *The Last Judgment* (fig. 667; p. 468) on the altar wall of the _____, typifies the style of Mannerism.

19. Until the nineteenth century, most Westerners based their concepts of _____ (p. 464) entirely upon the travel accounts of Marco Polo.

20. From 960 until 1279, the Taoists in China (p. 465) emphasized the importance o _____ _____, thus most important state positions were held by poets, calligraphers, and painters.

True False Questions

21. One of the leading innovators of the arts in early fifteenth century Florence (p. 456) was Titian. T_____ F_____

22. Brunelleschi is credited with having invented (p. 456) linear perspective. T_____ F_____

23. Pre-Columbian refers to the cultures of peoples living in Mexico, Central America, and South America (p. 466) prior to European arrival. T_____ F_____

24. The three major Pre-Columbian cultures of Mexico (p. 466) were the Toltec, the Inca, and the Durer. T_____ F_____

25. After the High Renaissance in Italy, many artists embarked on a style
 (p. 468) that was highly individualistic and consciously artificial. T____ F____

Short Answer Questions

26. What agency (p. 470) started the style noted for its theatricality and drama?

27. Northern Renaissance painters had the benefit of the new medium of oil paint (p. 458); what
 were its two main beneficial qualities?

28. Despite Caravaggio's desire to secularize his religious subjects (pp. 472-473), how does
 "spirituality" find its way into his works?

29. Why did a different type of painting thrive in Northern Europe (p. 474) during the Baroque?

30. Of all the new secular subjects that arose during the Baroque (p. 474), which one perhaps
 most decisively marked a shift in Western thinking?

Chapter 21 – The Eighteenth and Nineteenth Centuries

Multiple Choice Questions

1. In Jean-Auguste-Dominique Ingres' *Grand Odalisque* (fig. 689; p. 482) the subject is a:
 (a) Venus
 (b) harem slave
 (c) countess
 (d) self-portrait

2. Gustave Courbet's *Burial at Ornans* (fig. 699; p. 488) presents death as that which promises the "eternal reward" of:
 (a) an ideal realm
 (b) burning in damnation
 (c) a hole in the ground
 (d) perpetual bliss

3. In Edouard Manet's *Olympia* (fig. 702; p. 490), the painter was denying traditional painting style, and drawing attention to:
 (a) formal concerns within the composition
 (b) vivid colors
 (c) history painting
 (d) the fact that he was breaking with the past

4. Paul Gauguin's *The Day of the God* (fig. 710; p. 495) rejects modern society and paints images of "primitive" island culture such as this one in order to:
 (a) capture mystery and magic
 (b) portray paradise on earth
 (c) capture a world of unity
 (d) all of these

5. In Paul Cezanne's *The Large Bathers* (fig. 714; p. 496) there is an overall emphasis on:
 (a) form
 (b) proletarian actuality
 (c) optical mixing
 (d) flickering light

6. Marie-Louise-Elizabeth Vigee-LeBrun's *The Duchess of Polignac* (fig. 685; p. 479) combines Baroque tools of:
 (a) Rembrandt's dramatic lighting
 (b) Rubens's sensual curves
 (c) Bernini's sense of theatrical moment
 (d) all of these

7. Angelica Kauffmann painted in the Neoclassical style (fig. 687; pp. 480-481), which much of the time had as its subject:
 (a) the sublime
 (b) virtue
 (c) eroticism
 (d) slavery

8. Gericault's famous *Raft of the Medusa* (fig. 692; p. 484) helped to fuel the Romantic movement with the:
 (a) beauty of its landscape
 (b) idealism of its virtue
 (c) passion of its feelings
 (d) stability of its harmony

9. The Rococo style (p. 479) has been characterized as the Baroque eroticized, particularly in the art mode of:
 (a) sculpture
 (b) painting
 (c) architecture
 (d) theatre

10. The Rococo (p. 479) has been characterized as an extension of Borromini's curvilinear style, particularly in:
 (a) sculpture
 (b) painting
 (c) architecture
 (d) theatre

11. Thomas Jefferson brought the Neoclassical architectural style (p. 481) to the United States because:
 (a) Washington wanted him to
 (b) it was the style he grew up with
 (c) it was less expensive for the young government to build
 (d) the Greek orders embodied democratic ideals

12. In Romanticism (p. 483), regardless of the subject matter, the one attribute that reigned supreme was:
 (a) political opinion
 (b) individualism
 (c) religious orientation
 (d) Baroque reaction

13. The Post-Impressionists (p. 494) were united by their interest in extending Impressionism's formal innovations, and in reexamining the:
 (a) Realist painting style
 (b) nature of religion
 (c) symbolic possibilities of painting
 (d) philosophy of Romanticism

14. Painters of the Realist movement (p. 489) insisted on recording:
 (a) accurate notations of daily life
 (b) the pantheistic aspects of nature
 (c) elements of heroic nationalism
 (d) allegorical portents

15. In the early nineteenth century in Romantic painting, a recurrent theme (p. 485) was the sublime, which presented:
 (a) the vanity of mortal life
 (b) virtuous loves of the gods
 (c) the opulent lifestyle of the French monarchy
 (d) viewers with something vaster than themselves

Fill-in-the-Blank Questions

16. Soon after the discoveries of Herculaneum and Pompeii, a new classical style (p. 480) reappeared and the_____ style began to be regarded as decadent.

17. Baudelaire's chosen painter was Edouard Manet (p. 489) when he said "It is necessary to be__
 _____."

18. Paul Cezanne (p. 495) emphasized the formal aspects of painting at the expense of _____
 _____.

19. Toulouse-Lautrec (fig. 709; pp. 494-495) painted the decadence of the Parisian nightlife, and thus returned to direct criticism of _____.

20. David's *Death of Marat* (fig. 686; p. 480) celebrates a fallen hero of the French Revolution slain in his bath by_____.

True False Questions

21. Louis XIV considered Bernini's plans (p. 476) for the construction
 of the Louvre to be too simple. T_____ F_____

22. Poussin believed that the aim of painting (p. 477) was to represent
 the noblest human actions. T_____ F_____

23. Charles Lebrun considered the Greeks and Romans (pp. 478) to
 be the worst painters because they favored landscape and still life. T_____ F_____

24. Rubens's work (p. 478) is restrained and defined by linear clarity. T_____ F_____

25. The age of the Rococo (p. 479) was obsessed with sensuality. T_____ F_____

Short Answer Questions

26. Rococo is derived from the French *rocaille* (p. 479), which refers to what?

27. How does Clodion's *Nymph and Satyr Carousing* (fig. 684; p. 479) manage some degree of respectability in spite of its apparent eroticism?

28. Why did Jacques-Louis David (p. 480) take an active part in the French Revolution?

29. How did David pose the subject in the *Death of Marat* (fig. 686; pp. 480-481)?

30. Why is Georges Seurat's *The Bathers* (fig. 711; p. 495) a subtle critique of the image of Impressionist leisure?

Chapter 22 – The Twentieth Century

Multiple Choice Questions

1. George Braque's *Houses at L'Estaque* (fig. 715; p. 498) presents us with an early example of the style that was to become:
 (a) Art Nouveau
 (b) Fauvism
 (c) Expressionism
 (d) Cubism

2. Wassily Kandinsky's *Sketch I for Composition VII* (fig. 718; pp. 500-501) is an example of Expressionism; the artist considered his painting equivalent to:
 (a) the cone and the sphere
 (b) morality
 (c) music
 (d) reality

3. Giacomo Balla's *Dynamism of a Dog on a Leash* (fig. 720; p. 502) captures the Futurist fascination with movement, and demonstrates its debt to:
 (a) Cezanne
 (b) photography
 (c) Surrealism
 (d) Expressionism

4. Marcel Duchamp's *Mona Lisa L.H.O.O.Q.* (fig. 722; p. 504) exemplifies the Dada movement, and thus it championed:
 (a) form and structure
 (b) dream reality
 (c) irreverence toward tradition and logic
 (d) color and movement

5. Pablo Picasso's *Guernica* (fig. 726; p. 506) represents a tragic event in the Spanish Civil War, and is one of the greatest paintings of:
 (a) Surrealism
 (b) Dadaism
 (c) Analytic Cubism
 (d) Vorticism

6. Jackson Pollock's *Convergence* (fig. 734; p. 510) is an Abstract Expressionist work; the artist was deeply indebted to:
 (a) Suprematism
 (b) bullfighting
 (c) Futurist relativity
 (d) Surrealist automatism

7. Cindy Sherman's *Untitled #96* (fig. 722; p. 517) is actually a performance self-portrait, and as a work of contemporary art it struggles with the question of:
 (a) form
 (b) identity
 (c) color fields
 (d) action painting

8. Jenny Holzer is a postmodern artist (p. 521) in the sense that she uses the postmodern medium of electronic digital signboards; her work is thus:
 (a) transitory
 (b) immediate
 (c) site-specific
 (d) all of these

9. Henri Matisse (p. 499) was the founder of Fauvism because he felt free to use color arbitrarily, under the influence of:
 (a) Manet
 (b) Courbet
 (c) van Gogh
 (d) Futurism

10. Under the influence of Paul Cezanne, two artists who helped pioneer Cubism (pp. 497-498) were:
 (a) Braque and Picasso
 (b) Matisse and Gauguin
 (c) Bernheim and Jeune
 (d) Pollock and Dali

11. Using random, thoughtless notation of any kind (p. 505) in art is called automatism, which was popular with the:
 (a) Transitionalists
 (b) Surrealists
 (c) fauvists
 (d) Constructivists

12. Marinetti, Balla, and Boccioni (p. 502) were interested in certain new aspects of the 20th century, most particularly in movement and speed; their movement was called:
 (a) Synthetism
 (b) Vorticism
 (c) Pittura Metafisica
 (d) Futurism

13. Dada was a reaction (pp. 503-504) to the apparent bankruptcy of Western thought and failure of modern progress as represented by World War I; its chief strategy was:
 (a) to slip into a dream-world
 (b) to concentrate on form only
 (c) insult and outrage
 (d) replications of nature

14. Abstract Expressionism (pp. 510-512) was the major art movement of:
 (a) the 1950's
 (b) the 1960's
 (c) Romanticism
 (d) 1850's

15. In order for painting to dwell on form and be primarily about painting, the Cubists (p. 499) freed painting from the necessity to:
 (a) convey the pantheistic spirit
 (b) represent the world
 (c) concentrate on content
 (d) express autobiographical emotions

Fill-in-the-Blank Questions

16. The simultaneous presence of diverse traditions in a single work (p. 515) is indicative of the style of _____.

17. In 1924 Andre Breton issued the First Surrealist Manifesto (p. 505) that described the future resolution between the two seemingly contradictory states of _____ and _____.

18. Minimalism and Pop Art (p. 513) were the two major art movements of the decade of the _____.

19. The artist who encouraged future generations of painters to study nature (p. 498) in terms of the cylinder, the sphere, and the cone was _____.

20. For the painter Wassily Kandinsky (pp. 500-501), each _____ and _____ carried explicit expressive meaning.

True False Questions

21. In 1919, an Italian poet named Filippo Marinetti (p. 502) published a manifesto announcing the creation of Surrealism. T_____ F_____

22. The anti-art movement (p. 504) founded in Zurich, Berlin, Paris, and New York during World War I was called Dada. T_____ F_____

23. In the 1970's feminist artists objected to an art world (p. 515) dominated by men concerned mostly with formal issues. T_____ F_____

24. Judy Chicago's *The Dinner Party* (fig. 745; pp. 516-517) contributed to the growing acceptance of the culinary arts. T_____ F_____

25. Jimmie Durham (pp. 514-515) has created "fake" artifacts. T_____ F_____

Short Answer Questions

26. Who was acknowledged by the Surrealists themselves (p. 505) as an important precursor to the Surrealist movement?

27. In Miró's *Painting* (fig. 725; pp. 505-506) everything in the composition seems to fluctuate how?

28. Surrealist art was born of Dada (p. 505), and its preoccupations with what?

29. How were Piet Mondrian's aims as a painter (pp. 508-509) similar to those of the Suprematists before him?

30. How did the scale models function for Frank Gehry in the designing of the Guggenheim Museum Bilbao (fig. 754; p. 520)?

Chapter One
Answer Key

1. (d)
2. (c)
3. (b)
4. (a)
5. (c)
6. (b)
7. (c)
8. (d)
9. (a)
10. (b)
11. (d)
12. (b)
13. (a)
14. (d)
15. (c)

16. psychological
17. editing
18. sublime
19. flags
20. community life
21. tangible form
22. calligraphy
23. nurturing
24. generative
25. world

26. False
27. True
28. False
29. True
30. False

31. crucial differences between the two cultures
32. the vastness of the unexplored American West
33. the nation itself
34. the most bland, plain, and uninteresting view
35. the geological history of its place

Chapter Two
Answer Key

1. (d)
2. (b)
3. (c)
4. (a)
5. (d)
6. (c)
7. (b)
8. (b)
9. (d)
10. (a)
11. (c)
12. (c)
13. (d)
14. (b)
15. (a)

16. visual literacy
17. photographer
18. wrong
19. presence of Christ
20. ledger
21. depicts
22. Malevich
23. Chartres
24. *baum*; *arbre*
25. felt

26. True
27. False
28. True
29. False
30. False

31. to separate it from the "real"
32. to underscore its ceremonial function
33. psychological reality within
34. a betrothal
35. "that which is material into that which is immaterial"

Chapter Three
Answer Key

1. (a)
2. (c)
3. (b)
4. (d)
5. (c)
6. (b)
7. (d)
8. (a)
9. (b)
10. (d)
11. (c)
12. (a)
13. (d)
14. (b)
15. (c)

16. skull
17. represent everyday life
18. Santa Claus
19. worldly things
20. overblown emotionalism
21. personality and temperament
22. photography
23. impasse
24. *Desolation*
25. rock-topped mountain

26. False
27. True
28. True
29. False
30. True

31. abstract
32. his dignity and status
33. hospital chapel
34. clothing
35. the objects before her

Chapter Four
Answer Key

1. (c)
2. (b)
3. (d)
4. (a)
5. (b)
6. (d)
7. (c)
8. (a)
9. (b)
10. (d)
11. (d)
12. (c)
13. (b)
14. (b)
15. (c)

16. The Names Project
17. modern art
18. Krzysztof Wodiczko
19. chronophotographs
20. Arts in Public Places Program
21. "border"
22. border crossings
23. seven-foot-tall figures
24. activist
25. transformation

26. False
27. True
28. True
29. True
30. False

31. Raphael
32. experiencer, reporter, analyst, activist
33. its apparently "slipshod" technique
34. as looking "with open eyes"
35. his own modernity

Chapter Five
Answer Key

1. (a)
2. (c)
3. (d)
4. (b)
5. (c)
6. (b)
7. (d)
8. (a)
9. (c)
10. (c)
11. (d)
12. (b)
13. (a)
14. (d)
15. (c)

16. classical
17. tool
18. outlines
19. grid
20. dancer moving through space
21. fundamental
22. composition
23. *nature morte*
24. contour
25. symmetrical triangles

26. True
27. False
28. True
29. True
30. False

31. more spontaneously and casually
32. vertical and horizontal
33. reason and power
 or strength and rationality
34. sensuality and submissiveness
35. gesture

Chapter Six
Answer Key

1. (b)
2. (c)
3. (d)
4. (a)
5. (d)
6. (c)
7. (b)
8. (b)
9. (d)
10. (a)
11. (b)
12. (c)
13. (d)
14. (d)
15. (a)

16. illusion
17. flat, two-dimensional surface
18. axonometric
19. mathematically codified
20. vanishing point
21. shape
22. two-point
23. Christ
24. refectory
25. mass

26. False
27. True
28. True
29. False
30. True

31. directly across from the viewer
32. diagonal
33. frontal
34. the reserve
35. overlap

Chapter Seven
Answer Key

1. (b)
2. (c)
3. (d)
4. (a)
5. (b)
6. (b)
7. (a)
8. (d)
9. (c)
10. (b)
11. (d)
12. (a)
13. (c)
14. (b)
15. (d)

16. chartreuse
17. palette
18. cast shadow
19. shade
20. tint
21. human eye
22. white light
23. grey
24. red
25. orange

26. False
27. True
28. False
29. True
30. False

31. palette
32. simultaneous contrast
33. expressive visual tension and
 emotional imbalance
34. colors of the modern world
35. flux and flow or
 energy and dynamism

Chapter Eight
Answer Key

1. (a)
2. (c)
3. (b)
4. (d)
5. (c)
6. (b)
7. (a)
8. (b)
9. (d)
10. (d)
11. (b)
12. (d)
13. (a)
14. (b)
15. (c)

16. move
17. texture
18. impasto
19. visual texture
20. to rub
21. animal style
22. *Lindesfarne Gospels*
23. "femmage"
24. linear
25. narrative

26. False
27. True
28. False
29. True
30. False

31. Action Painting
32. a voice reading St. John's poetry
33. the end as we know it
34. encircle it
35. photography

Chapter Nine
Answer Key

1. (c)
2. (b)
3. (d)
4. (a)
5. (c)
6. (d)
7. (d)
8. (b)
9. (a)
10. (c)
11. (b)
12. (a)
13. (c)
14. (a)
15. (d)

16. unity
17. radial
18. symmetry
19. whole
20. totality

21. True
22. False
23. False
24. True
25. True

26. asymmetrical
27. heavier
28. complementary
29. Marie Antoinette
30. the visage of Christ

1. (b)
2. (c)
3. (d)
4. (a)
5. (d)
6. (c)
7. (d)
8. (b)
9. (a)
10. (b)
11. (d)
12. (c)
13. (b)
14. (d)
15. (b)

16. Edgar Degas
17. dry media
18. fluid or fast and expressive
19. feather
20. sprayed synthetic resin

21. True
22. False
23. False
24. True
25. False

26. a liquid binder
27. with metalpoint on parchment
28. chiaroscuro
29. Nicholas-Jacques Conté for Napoleon
30. how much binder is incorporated

Chapter Eleven
Answer Key

1. (c)
2. (b)
3. (d)
4. (a)
5. (b)
6. (c)
7. (c)
8. (d)
9. (a)
10. (b)
11. (b)
12. (c)
13. (d)
14. (a)
15. (a)

16. engraving
17. lithography
18. rocker
19. wood engraving
20. pulling

21. True
22. False
23. False
24. True
25. False

26. careful hatching in any direction
27. Thomas Moran
28. a burin
29. it has the immediacy of a sketch
30. her son Peter was killed in 1914

Chapter Twelve
Answer Key

1. (c)
2. (d)
3. (d)
4. (b)
5. (a)
6. (c)
7. (d)
8. (a)
9. (a)
10. (b)
11. (d)
12. (c)
13. (d)
14. (b)
15. (a)

16. imitation
17. substitute
18. Black Mountain College
19. gesture
20. painting

21. False
22. True
23. False
24. False
25. True

26. Siqueiros and the Mexican muralists
 or *Los Tres Grandes*
27. Duco; paint developed as automobile lacquer
28. multi-colored translucent washes
 thinned to the consistency of watercolor
29. a computer program and robot capable
 of generating unique paintings on canvas
30. they are more fluid or
 can be manipulated more easily

Chapter Thirteen
Answer Key

1. (c)
2. (b)
3. (d)
4. (a)
5. (b)
6. (c)
7. (d)
8. (a)
9. (b)
10. (c)
11. (c)
12. (d)
13. (a)
14. (b)
15. (c)

16. medicine
17. subtractive, additive
18. indoors
19. casting
20. Egyptian

21. True
22. True
23. False
24. False
25. True

26. "a sense of being on this planet,
 rotating in space, in universal time"
27. "anything is possible" or
 "vision or concept will come through total risk"
28. in relative isolation and silence,
 to move in and out of the grid,
 to experience the infinite
29. tractor and machine parts, logs, papier-mâché,
 and building materials
30. the tension in a figure

Chapter Fourteen
Answer Key

1. (b)
2. (c)
3. (d)
4. (a)
5. (d)
6. (c)
7. (b)
8. (d)
9. (a)
10. (d)
11. (d)
12. (b)
13. (b)
14. (c)
15. (a)

16. two-dimensional surface
17. glassy appearance
18. stoneware, porcelain
19. Romans
20. Islam

21. False
22. True
23. False
24. True
25. True

26. it violates the integrity of painting as a medium
27. John Cage's classes at the New School
28. it is his way of keeping in touch with "the limitless potential of original mind"
29. to make contact between the ancient and the modern
30. the way it is animated by light

Chapter Fifteen
Answer Key

1. (c)
2. (b)
3. (d)
4. (a)
5. (b)
6. (d)
7. (c)
8. (d)
9. (b)
10. (a)
11. (d)
12. (c)
13. (d)
14. (a)
15. (b)

16. photogenic drawing
17. sequences
18. disparate images
19. assemblage or collage
20. traveling

21. False
22. True
23. True
24. False
25. True

26. John Cage's *4'33"*
27. the clichéd mindlessness of commercial television
28. the viewer's sense of gravity
29. a cross, a vital or decisive point, something
 that torments by its puzzling nature, or the
 missing body of the artist in the center of the
 video screens
30. the aesthetic sense

Chapter Sixteen
Answer Key

1. (b)
2. (d)
3. (c)
4. (a)
5. (d)
6. (b)
7. (d)
8. (c)
9. (b)
10. (a)
11. (c)
12. (d)
13. (b)
14. (c)
15. (a)

16. Midwestern prairie landscape
17. buckling in the middle
18. structural systems
19. Ionic, Corinthian
20. entasis

21. False
22. False
23. True
24. True
25. False

26. early skeptics believed balloon-frame houses would explode
27. domestic architecture available to everyone
28. his ability to lighten the façade by multi-story window arcades
29. Le Corbusier's Villa Savoye and
 Mies van der Rohe's German Pavilion
30. the contrast between the openness provided by the windows
 and the sculptural mass of the reinforced concrete

Chapter Seventeen
Answer Key

1. (b)
2. (d)
3. (c)
4. (a)
5. (d)
6. (b)
7. (d)
8. (c)
9. (b)
10. (a)
11. (c)
12. (d)
13. (b)
14. (c)
15. (a)

16. Queen's Ware
17. Art Deco
18. William Morris
19. Burlington *Zephyr*
20. museum curator

21. False
22. True
23. True
24. False
25. True

26. into the factory
27. the beauty of its wood
28. Red Bolshevik cause, and the White Russian cause
29. the manual modes
 (i.e. handcrafted production styles)
30. a dynamic tension that might release their own
 creative energies

Chapter Eighteen
Answer Key

1. (c)
2. (b)
3. (c)
4. (d)
5. (a)
6. (b)
7. (d)
8. (d)
9. (b)
10. (d)
11. (a)
12. (c)
13. (d)
14. (b)
15. (a)

16. Greek architecture
17. Romans
18. permanent bliss
19. heaven and earth
20. democracy

21. False
22. False
23. True
24. False
25. True

26. individualism, reason, and accurate observation of the world
27. Aristotle persuaded Alexander the Great to impose Greek culture throughout his empire
28. because eye make-up was prepared on it
29. the earth itself
30. the desire to unify their country

Chapter Nineteen
Answer Key

1. (c)
2. (b)
3. (d)
4. (d)
5. (a)
6. (b)
7. (b)
8. (c)
9. (a)
10. (d)
11. (b)
12. (c)
13. (b)
14. (d)
15. (a)

16. glories
17. high naves
18. religious texts
19. Islam
20. Christianity

21. False
22. True
23. False
24. True
25. True

26. it became imperial art
27. visual rhythm realized through symmetry and repetition
 of certain patterns and motifs
28. it is more naturalistic, and figures assert their own individuality more, or
 Romanesque generalized "types" have disappeared,
 or the space between figures is bridged by shared emotion
29. the Mohammedan Caliphs
30. the spot in Mohammed's house at Medina where he stood
 to lead communal prayers

Chapter Twenty
Answer Key

1. (c)
2. (d)
3. (b)
4. (a)
5. (c)
6. (d)
7. (b)
8. (c)
9. (a)
10. (d)
11. (b)
12. (c)
13. (a)
14. (d)
15. (b)

16. in stone
17. southern Mexico and Guatemala
18. Sistine Chapel
19. China
20. self-expression

21. False
22. True
23. True
24. False
25. True

26. the papacy in Rome
27. dazzling effects of light of the painting's surface, and lends a sense of material reality to depicted objects
28. the treatment of light imbues them with a spiritual quality
29. Protestant theology purged churches of religious art, and classical subjects were considered pagan
30. landscape

Chapter Twenty-One
Answer Key

1. (b)
2. (c)
3. (d)
4. (d)
5. (a)
6. (d)
7. (b)
8. (c)
9. (a)
10. (c)
11. (d)
12. (b)
13. (c)
14. (a)
15. (d)

16. Rococo
17. "of one's own time"
18. subject matter
19. modern life
20. a Monarchist

21. False
22. True
23. False
24. False
25. True

26. small shells that decorate the interiors of grottoes
27. because of its Greek theme
28. he recognized the overthrow of the monarchy as an expression of true civic duty and virtue
29. like Christ in a Deposition
30. the bathers are workers not wealthy Parisians, and the water contains smelly sewage

Chapter Twenty-Two
Answer Key

1. (d)
2. (c)
3. (b)
4. (c)
5. (a)
6. (d)
7. (b)
8. (d)
9. (c)
10. (a)
11. (b)
12. (d)
13. (c)
14. (a)
15. (b)

16. Postmodernism
17. dream and reality
18. 1960's
19. Paul Cézanne
20. color and line

21. False
22. True
23. True
24. False
25. True

26. Giorgio de Chirico
27. being susceptible to ongoing mutation,
 between representation and abstraction
28. the irrational, the illogical, and in ideas
29. they were essentially ethical—he wanted to purify art
 in order to purify the spirit
30. the models are like sculpture:
 they allowed him to focus "on this sculpting process"